Gothic Dreams

Cthulhu

Dark Fantasy, Horror and Supernatural Movies

Publisher and Creative Director: Nick Wells
Project Editor and Picture Research: Laura Bulbeck
Art Director: Mike Spender
Digital Production: Chris Herbert

Special thanks to: Frances Bodiam, Catherine Taylor, Esme Chapman and the artists who
allowed us to reproduce their fantastic work

FLAME TREE PUBLISHING
Crabtree Hall, Crabtree Lane
Fulham, London SW6 6TY
United Kingdom

www.flametreepublishing.com
www.flametree451.com

First published 2014

14 16 18 17 15
1 3 5 7 9 10 8 6 4 2

A CIP record for this book is available from the British Library upon request.

Hardback ISBN 978-1-78361-218-5
Paperback ISBN 978-1-78361-264-2

Printed in China

Gothic Dreams

Cthulhu

Dark Fantasy, Horror and Supernatural Movies

GORDON KERR

Foreword by JOHN HARLACHER

FLAME TREE
PUBLISHING

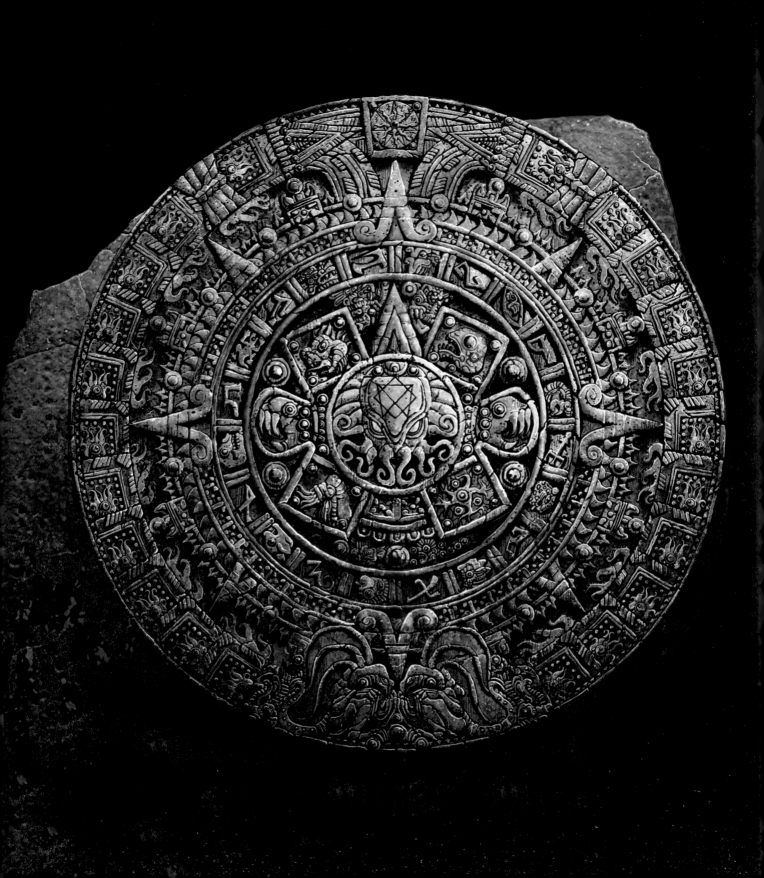

Contents

Foreword

When H.P. Lovecraft created Cthulhu it was the 1920s and it was amongst an atmosphere of new thinking, when the mind of humanity had been blown. The telescopes had seen a universe larger and stranger than expected, and Darwin's theories of evolution from a few decades before were entering the popular consciousness, dropping man's estimation of himself from a creature created as the masterpiece of some god's menagerie, to something common at best and meaningless at worst.

'The Call of Cthulhu' (published in **Weird Tales** magazine in 1928) was an expression of this feeling. In the story, a scholar discovers ancient creatures that lived far before mankind on this earth, and the cult devoted to reviving them. Man was made as an accident, and was to be casually wiped out. Fine. . . unusual enough at the time, but of course, the wiping out of humanity had to be done somehow. A virus? An asteroid? No. We would all be killed by this *Thing*. It had a fishlike head and a dragon body, they said. It was the high priest of a unknown religion. It was enormous. If you saw it you would instantly go insane. It slept under the ocean, and when the stars were right, it would emerge. **Cthulhu**.

Now when you think about this, it seems ridiculous. Is the giant monster going to eat all of us one by one? Surely he is a metaphor for some force of nature. Or is he a creature that commands the forces of nature? The correct answer, is none of your goddamn business. You will find out. **Weird Tales** magazine has seen Cthulhu appear time and again, having escaped Lovecraft's work to invade the stories of other writers (with Lovecraft's blessing), and has similarly come to invade popular culture. He has appeared on South Park and as an internet meme, and some say the horror has been sucked from his image.

But Cthulhu still sleeps, dreaming. He knows better.

John Harlacher
Publisher and Creative Director, **Weird Tales** magazine

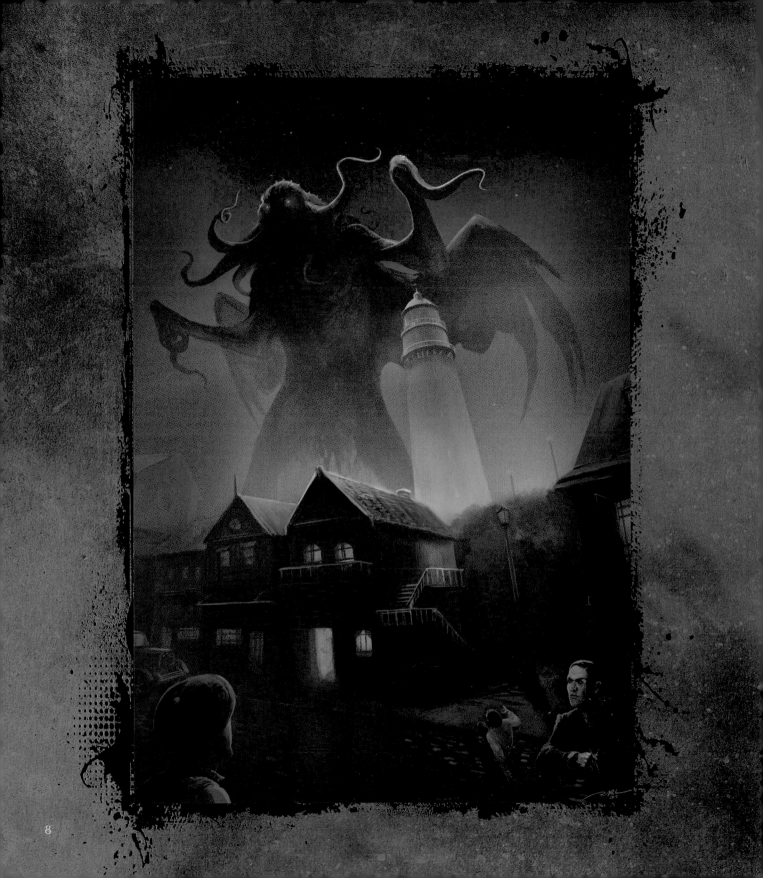

The Call of Cthulhu

Entombed in the slimy vaults of the mysterious city of R'lyeh, deep beneath the angry waves of the Pacific Ocean, sleeps a nightmarish creature. Possessing power beyond the imagining of man, Cthulhu has passed eons in his watery prison, awaiting the alignment of the stars to present him with the opportunity to awaken and reclaim his fearsome dominion over our world.

Cthulhu is the creation of Howard Phillips Lovecraft – 'H.P. Lovecraft' to his friends – an American author who worked in the genre known as 'weird fiction' – a sort of hybrid of horror and fantasy. Lovecraft not only created the bizarre, tentacle-mouthed Cthulhu, he invented a fantastic universe of extraterrestrial creatures that, he wrote, once ruled over the earth. He encouraged other writers to share this world, allowing them to add to or borrow from his imaginings. Eventually, August Derleth, a contemporary correspondent of Lovecraft, coined the term 'Cthulhu Mythos' to describe this macabre shared fictional universe.

Even after Lovecraft's death in 1937, Cthulhu has continued to grip the world's imagination, becoming something of a cult to some devotees. Meanwhile, countless writers have conspired to expand the Cthulhu Mythos, bringing new horrors to expectant hordes of fans. Websites, books, videos and games have further extended the Cthulhu canon.

But still, great Cthulhu sleeps, awaiting his moment...

'Searchers after horror haunt strange, far places.'

H.P. Lovecraft, 'The Picture in the House'

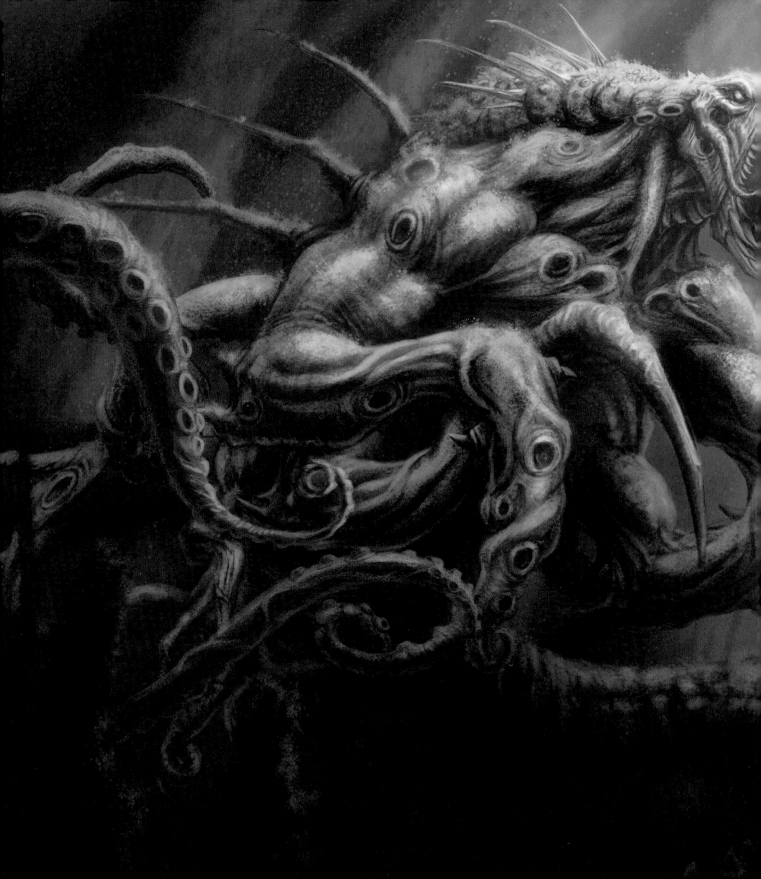

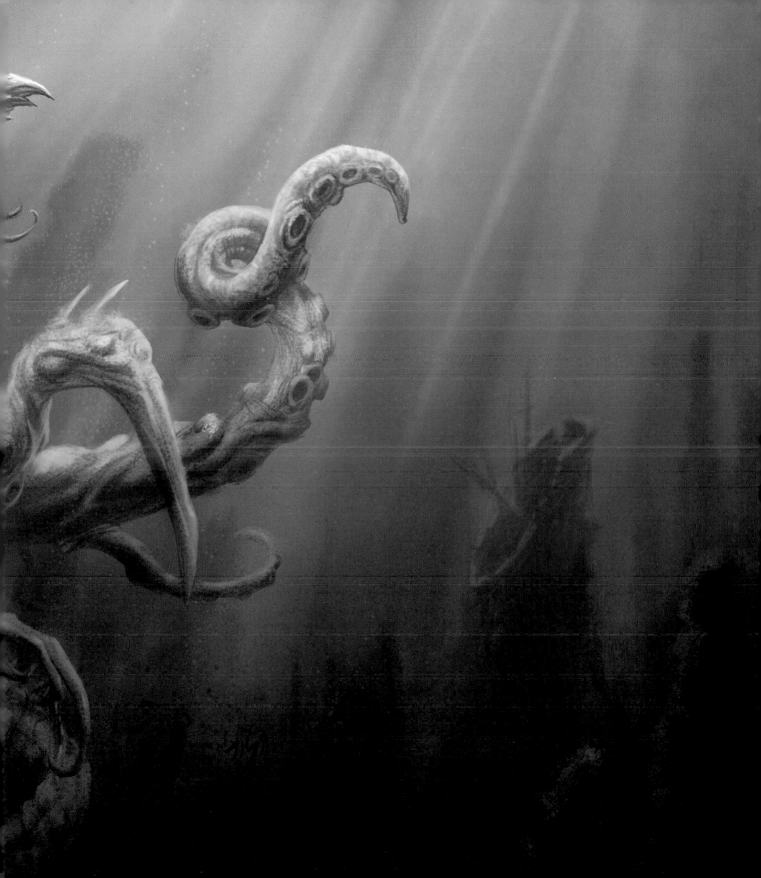

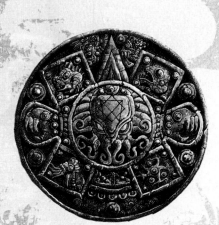

Master of Horror

H.P. Lovecraft really should have got out more. Or, at least, he should have got out more between 1908 and 1913 when he rarely ventured across the threshold, and if he did it was only after nightfall. This might go some way to explaining the dark eyes and gaunt, pale face. These years after leaving school were spent living an isolated, friendless existence in Providence, Rhode Island, with only his mother for company, writing poetry in his room and serving as a prototype for the modern 'nerd'.

Born in August 1890, Lovecraft was raised after the death of his father in a mental institution by his neurotic mother, two aunts and his grandfather, wealthy businessman Whipple Van Buren Phillips, who encouraged the young Lovecraft's interest in classical literature and English poetry.

Early Influences

The earliest influence on his later work was the *Arabian Nights* which he had devoured by the time he was five. He invented the pseudonym 'Abdul Alhazred' around this time, the name later ascribed to the writer of the *Necronomicon*, the fictional grimoire that would appear in many stories of the Cthulhu Mythos. His Arabian passion was soon eclipsed by the

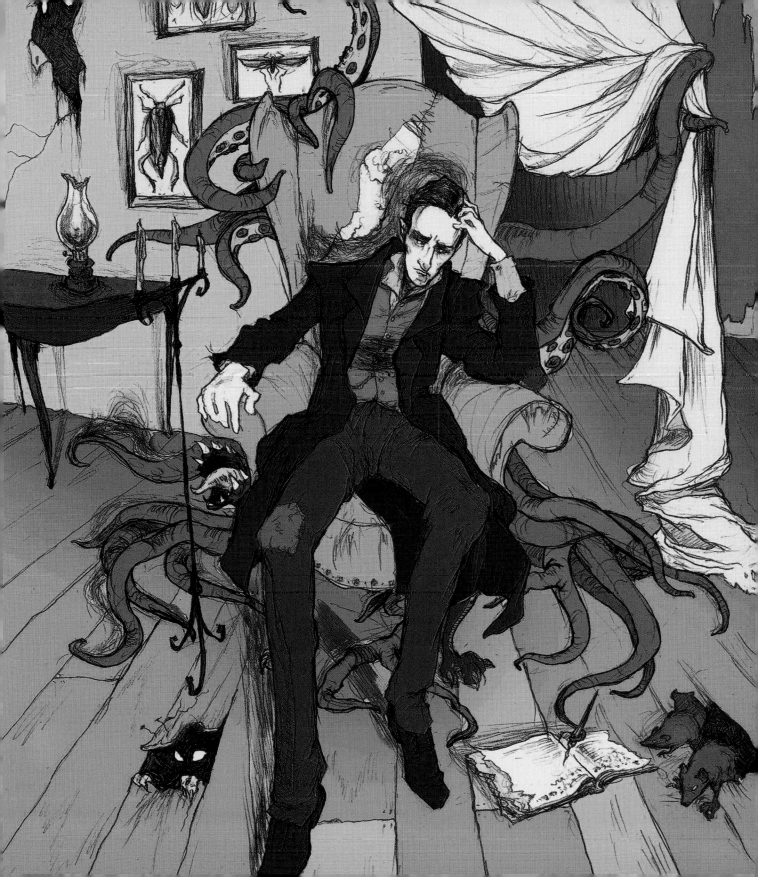

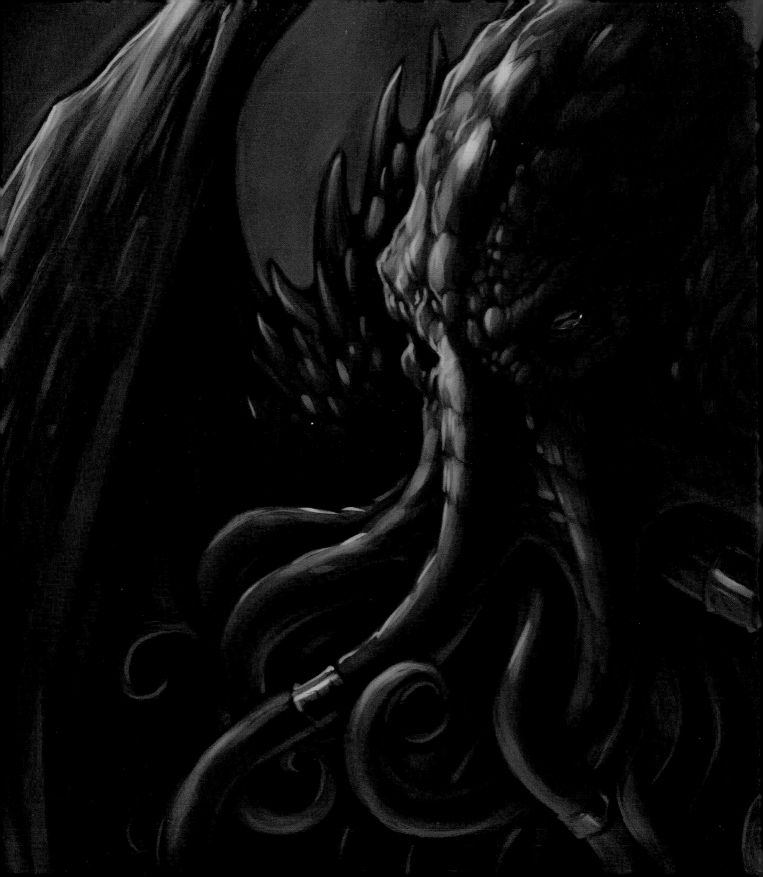

fantastic adventures of gods and men in Greek mythology and his prodigious literary skills were already on show at the age of seven when he paraphrased the **Odyssey** in the eighty-eight lines of 'The Poem of Ulysses', his earliest surviving literary effort.

Gothic Tales and Weird Dreams

But, even at that early age, his own imagination was the source of many of the odd creatures and situations he created, especially his wild dreams, suspected to have been caused by the sleep disorder known as night terrors. These nocturnal adventures undoubtedly had an influence on his later work. He described the content of his weird dreams as: 'Space, strange cities, weird landscapes, unknown monsters, hideous ceremonies, Oriental and Egyptian gorgeousness, and indefinable mysteries of life, death and torment, were daily – or rather nightly commonplaces to me before I was six years old.'

Meanwhile, his fondness for what is now termed 'weird fiction' was already being nurtured by his grandfather who thrilled and terrified him with strange Gothic tales of his own invention. At the age of six, he wrote his first story, 'The Noble Eavesdropper', now lost.

Lost Fortune

When his grandfather died in 1904, 4 year-old Lovecraft was devastated, but so were the family's finances, as mismanagement of Whipple Phillips' estate led to his

> *'I was nearly unnerved at my proximity to a nameless thing at the bottom of a pit.'*
>
> H.P. Lovecraft,
> 'The Shunned House'

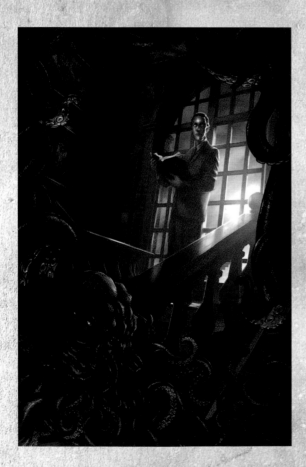

fortune being squandered. Lovecraft and his mother moved into humble accommodation, and eventually he suffered a nervous breakdown, failing to graduate from high school as a result. His dream of becoming a professional astronomer faded as quickly as the stars at dawn.

In 1913, Lovecraft emerged from his five years of isolation with a letter to the pulp magazine **The Argosy**, in which he complained about its insipid love stories. The ensuing debate in the letters page of the magazine led to him being invited to join the United Amateur Press Association, a group that provided a forum for like-minded people to discuss common interests; like an electronic bulletin board long before the invention of the internet.

Prolific Correspondent

Lovecraft was reinvigorated, and after contributing many essays and poems, in 1916 his first story – 'The Alchemist' – was published in the **United Amateur**. His first commercially published work came in 1922 when he was 31 years old. By then, however, he had established a huge network of correspondents, and was writing the letters and notes that placed him amongst the twentieth century's greatest letter-writers. He is thought to have written around 100,000 letters in his lifetime. He shared ideas with, and provided encouragement to, numerous writers, amongst whom were Robert Bloch, best known as the author of **Psycho**, the American author and poet Clark Ashton Smith and Robert E. Howard, author of the 'Conan the Barbarian' series.

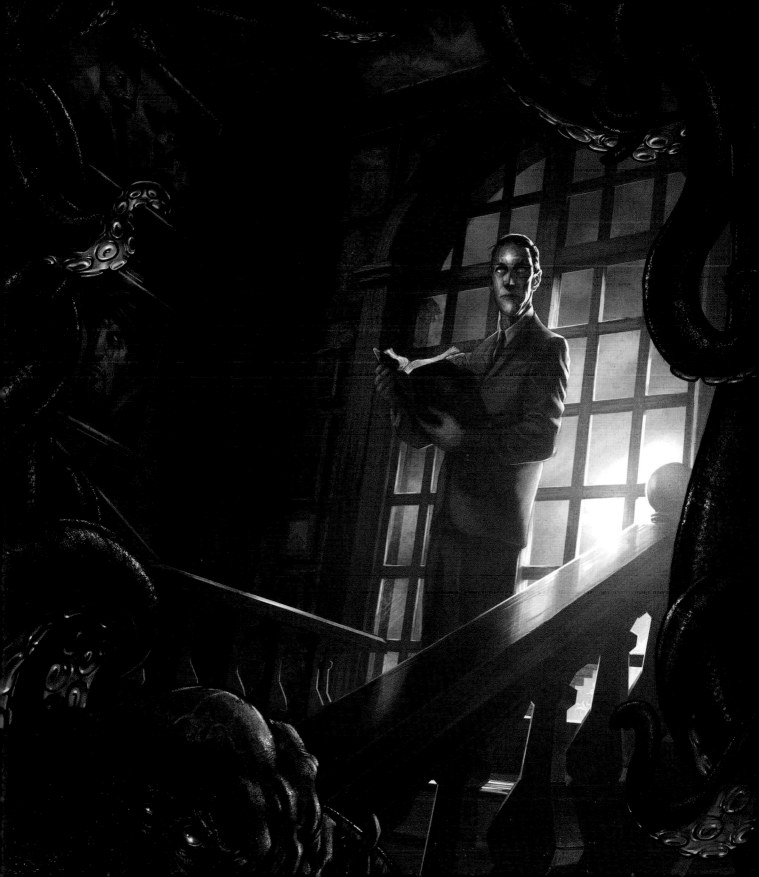

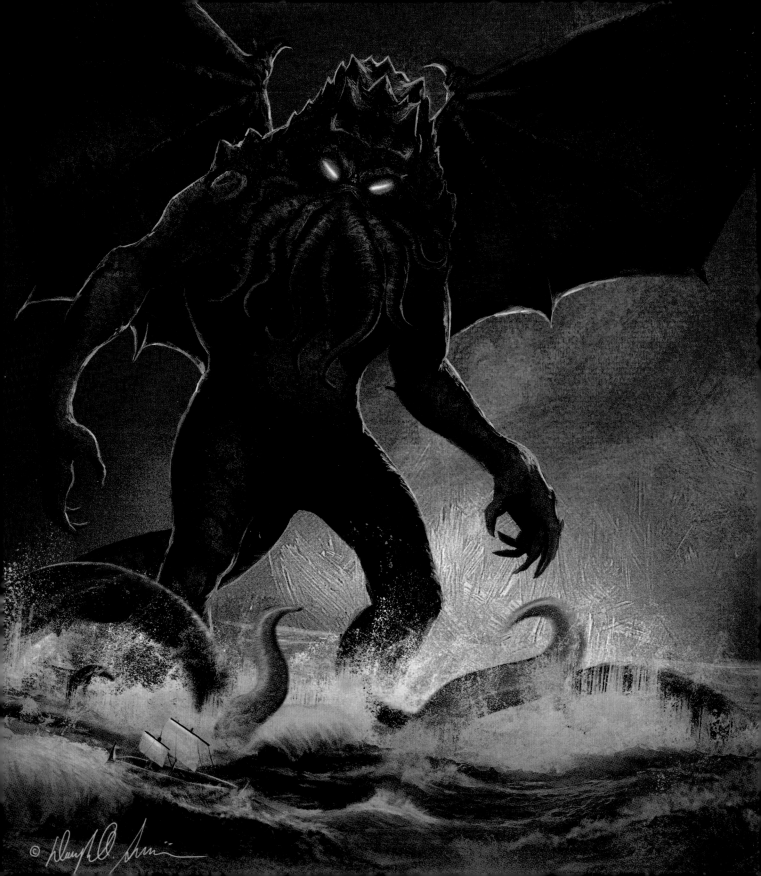

New York, New York

Lovecraft married in 1924 and re-located to Brooklyn, New York, but the marriage was brief, and Lovecraft hated New York. The story 'The Horror at Red Hook' best sums up his feelings about the city; the story's narrator says: 'My coming to New York had been a mistake; for whereas I had looked for poignant wonder and inspiration ...I had found instead only a sense of horror and oppression which threatened to master, paralyze, and annihilate me'.

Return to Providence

In 1926, Lovecraft returned to Providence and the most prolific period of his literary career, producing many short stories as well as the novellas **The Case of Charles Dexter Ward**, which was published posthumously in **Weird Tales** magazine in May and June 1941, and **At the Mountains of Madness**. In 1928, he wrote 'The Call of Cthulhu'.

During this time he had to live frugally, sometimes missing meals in order to be able to afford stamps for the huge number of letters he continued to send. He died of cancer on March 15, 1937 and in 1977 fans raised enough money to provide him with his own headstone in Swan Point Cemetery. On it was inscribed the line 'I AM PROVIDENCE', a quote from one of his letters.

Weird Tales, May 1941.

'I shall never sleep calmly again when I think of the horrors that lurk …and of those unhallowed blasphemies from elder stars which dream beneath the sea.'

H.P. Lovecraft,
'The Call of Cthulhu'

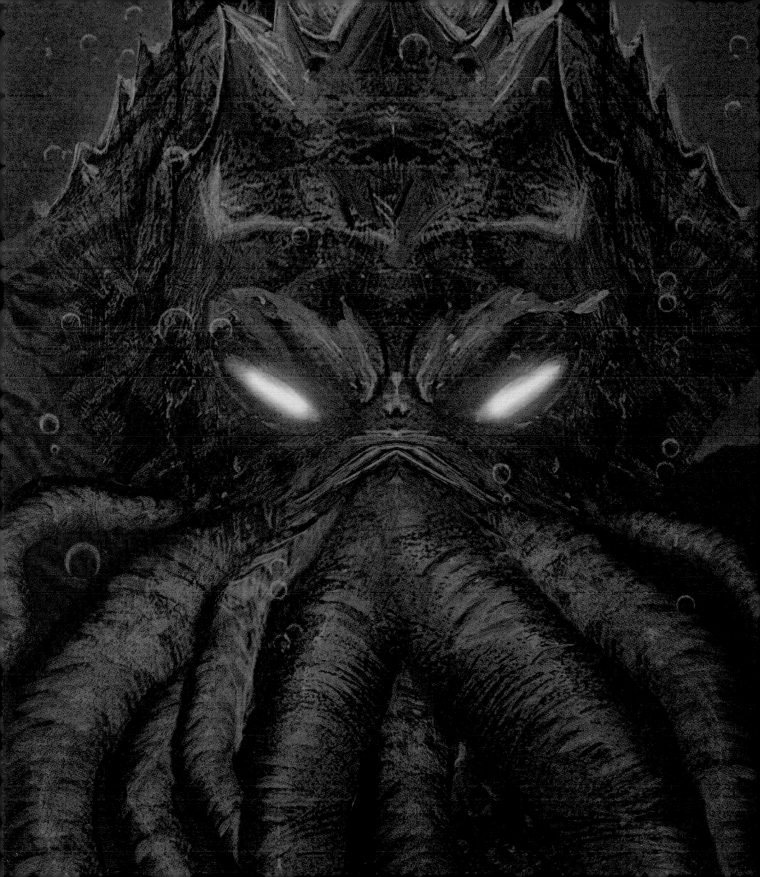

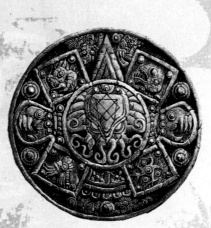

Creating Cthulhu

So, where did Lovecraft dredge the horror of Cthulhu up from? One respected scholar of the Cthulhu Mythos, Robert M. Price, cites the sonnet 'The Kraken', written in 1830 by Alfred Tennyson as a big influence. The Kraken of the poem is a legendary, gigantic sea monster, resembling a giant squid, dwelling off the coasts of Norway and Greenland in 'ancient, dreamless, uninvaded sleep'. Like Cthulhu, it is said that the Kraken will appear in apocalyptic times.

Guy de Maupassant's 1887 short story 'The Horla' excited his interest, for instance. He provided an interpretation of the story in a review in his survey 'Supernatural Horror in Literature', describing how it related 'the advent in France of an invisible being who...sways the minds of others, and seems to be the vanguard of a horde of extraterrestrial organisms arrived on earth to subjugate and overwhelm mankind'. Just like someone we know.

A Monster from Literature

There were many other literary influences at work on Lovecraft's imagination. French writer

Random Knowledge

The Welsh author and mystic Arthur Machen described the survival of a horrifying ancient

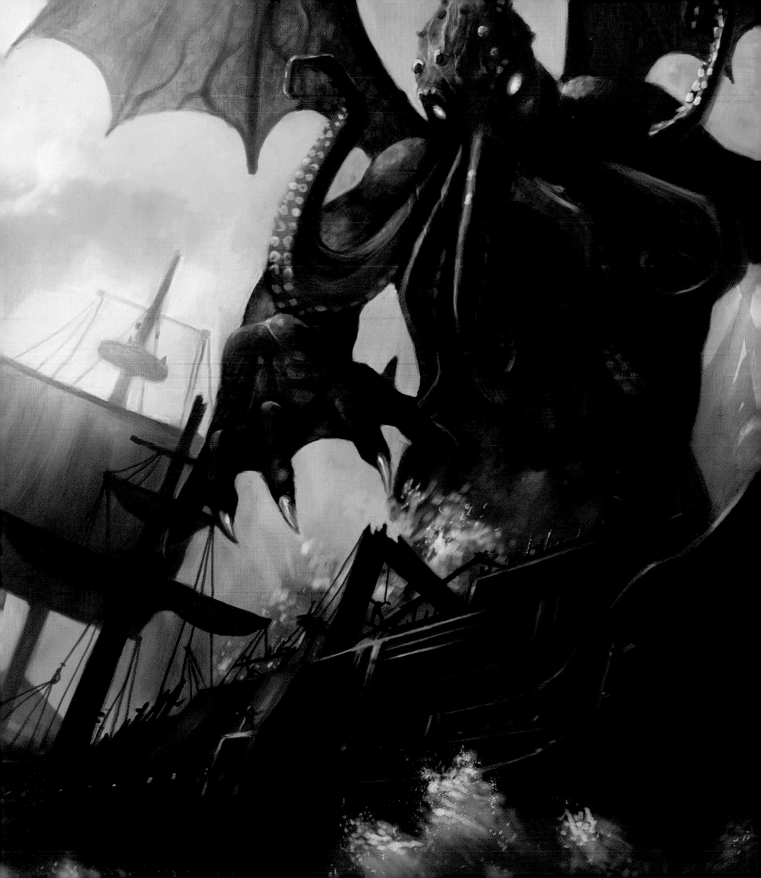

being in his **Novel of the Black Seal**, using the method of piecing together random knowledge that Lovecraft also enjoyed playing with. William Scott-Elliot's **The Story of Atlantis** of 1896 and **The Lost Lemuria** were Lovecraft's bedtime reading shortly before he started to write 'The Call of Cthulhu'.

The Tentacle

William Hope Hodgson was another author of fantasy and horror who undoubtedly attracted Lovecraft's attention. Hodgson had been a sailor and used his maritime experiences to colour his novels and stories. English fantasy fiction writer China Miéville reckons that Lovecraft borrowed the idea of using the tentacle as an object of horror from Hodgson.

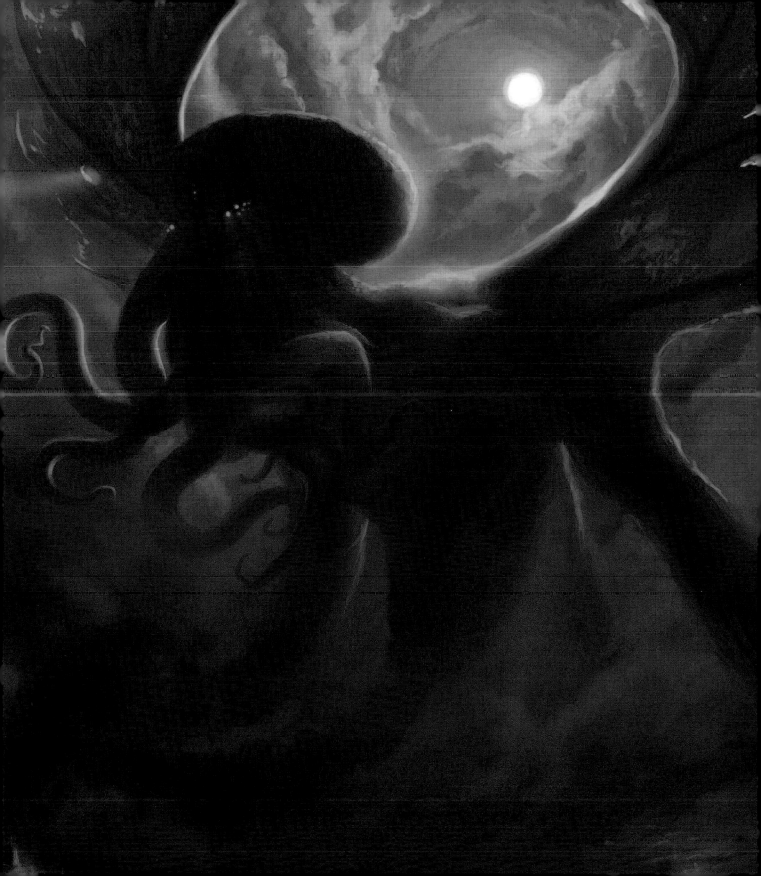

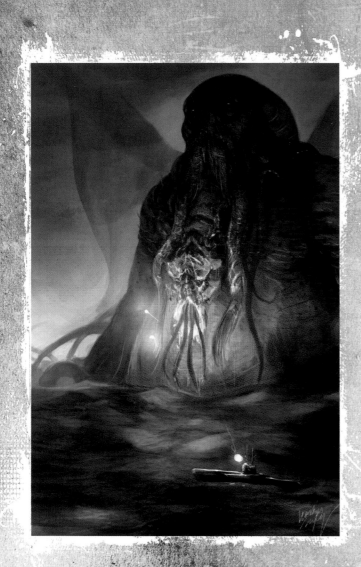

a grimoire written by an unknown author with an introduction by a man known only as 'Simon'. Simon claims that Cthulhu derives from the Sumerian word, Kutulu, suggesting that Lovecraft's studies of ancient history took him in that direction.

What's in a Name?

Okay, so it's not the easiest word to pronounce, but surely any monster worth his salt deserves an unpronounceable name. Lovecraft himself had problems with it, using various pronunciations on different occasions. Of course, as he rightly pointed out, the language of the Old Ones is impossible for us mere mortals which means that our pathetic attempts to pronounce Cthulhu's name will always result in sniggering in the bars of Arkham. The most common pronunciation is 'khul-hoo'. Generally, however, he is referred to as 'kuh-THOO-loo'.

Looking Mighty Fine, Mr Cthulhu

So, what does he look like, this monster? In 'The Call of Cthulhu', Lovecraft describes him as 'A monster of vaguely anthropoid outline, but with an octopus-like head whose face was a mass of feelers, a scaly, rubbery-looking body, prodigious claws on hind and fore feet, and long, narrow wings behind.' He seems to be a mix of a number of things – octopus, human and dragon – and is several hundred metres tall. His head is octopus-like with tentacles surrounding his mouth. Don't be fooled, however. He has the ability to change shape and form at will, extending and retracting his limbs and tentacles as required.

The work of American writer Edgar Allan Poe, and Irish writer and dramatist Lord Dunsany also had a strong bearing on Lovecraft's work.

Sumerian Roots?

One particularly odd source for information about Cthulhu's origins is the 1977 book the **Simon Necronomicon**, allegedly

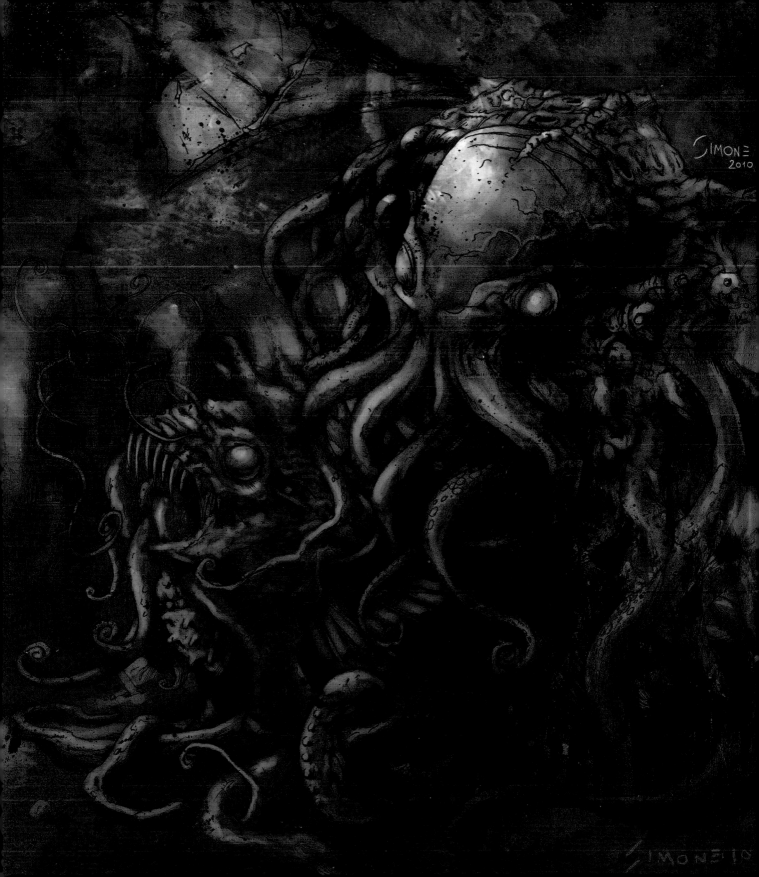

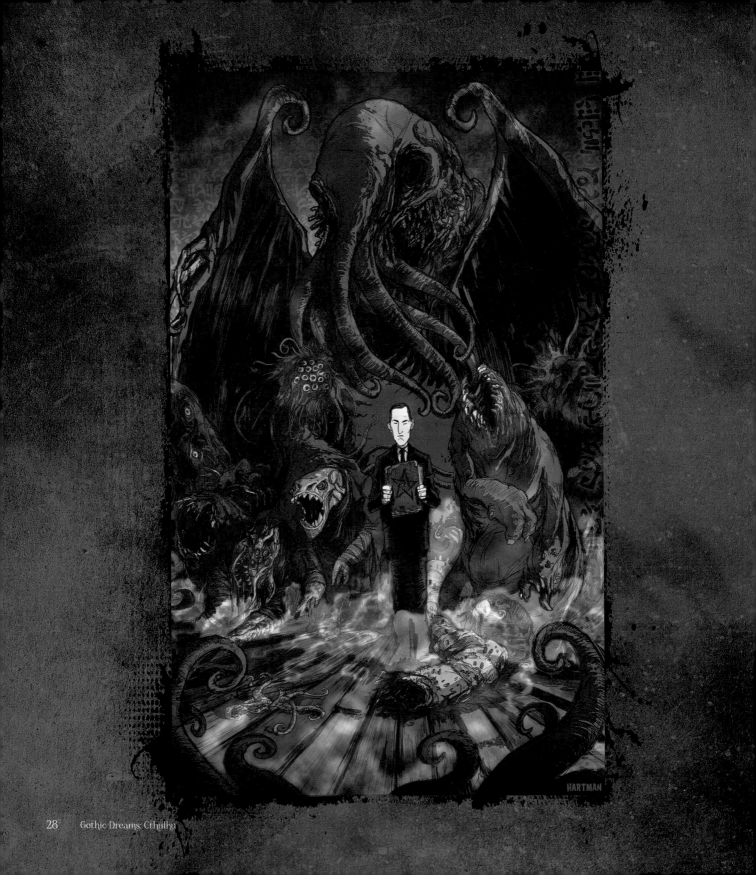

How Did It Start?

Lovecraft began to draft the outline of a story about Cthulhu while living in New York in around 1925. It was a story that would emphasize the insignificance of humanity in the face of more powerful cosmic forces. Others have seen deeper meanings, however. The French author Michel Houellebecq, who says in his book *H. P. Lovecraft: Against the World, Against Life* that each Lovecraft story is 'an open slice of howling fear', is struck by what he describes as Lovecraft's hatred of life and philosophical denial of the world.

Published in the magazine *Weird Tales* in February 1928, and described by Lovecraft only as 'rather middling', 'The Call of Cthulhu' tells of a manuscript found amongst the papers of the late Francis Wayland Thurston that talks about notes left behind by his great-uncle, George Gamell Angell. The first chapter describes a grotesque bas-relief sculpture executed by Henry Anthony Wilcox that has been found amongst the papers. Wilcox makes reference to the terms 'Cthulhu' and 'R'lyeh' and Angell discovers that there have been unexplained outbreaks of mental illness and hysteria around the world.

The Story Continues

The second chapter discusses an unidentifiable greenish-black stone sculpture, resembling that of Wilcox, seized during a raid on a voodoo gathering in swamps south of

Weird Tales, February 1928.

> '*I thought with a shudder of what Old Castro had told Legrasse about the Old Ones; "They had come from the stars, and had brought Their images with Them".*'

H.P. Lovecraft, 'The Call of Cthulhu'

New Orleans. The raid uncovered a number of dismembered bodies being used in a ritual around the stone and a group of men repeatedly chanting the strange phrase: 'Ph'nglui mglw'nafh Cthulhu R'lyeh wgah'nagl fhtagn'. It was learned that they were part of a cult that worshipped the Great Old Ones who had lived before man and now lay 'hidden in distant wastes and dark places all over the world until the time when the great priest Cthulhu, from his dark house in the mighty city of R'lyeh under the waters, should rise and bring the earth again beneath his sway.' The statuette which displayed an 'unnatural malignancy', was recognized as 'great Cthulhu'.

And Finally

The story's third chapter describes Thurston's investigation of the cult. He learns of the sole survivor of a sea battle between two ships, realizing that the man's ship had been sunk by a vessel connected to the Cthulhu cult. The survivor, Gustaf Johansen, had made it with other crew members to an island located at map coordinates 47°9'S 126°43'W, even though no islands had been charted in this

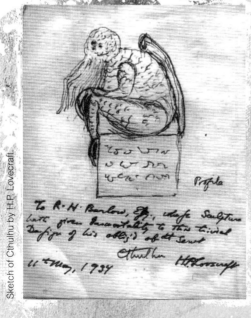

Sketch of Cthulhu by H.P. Lovecraft.

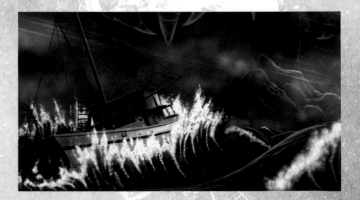

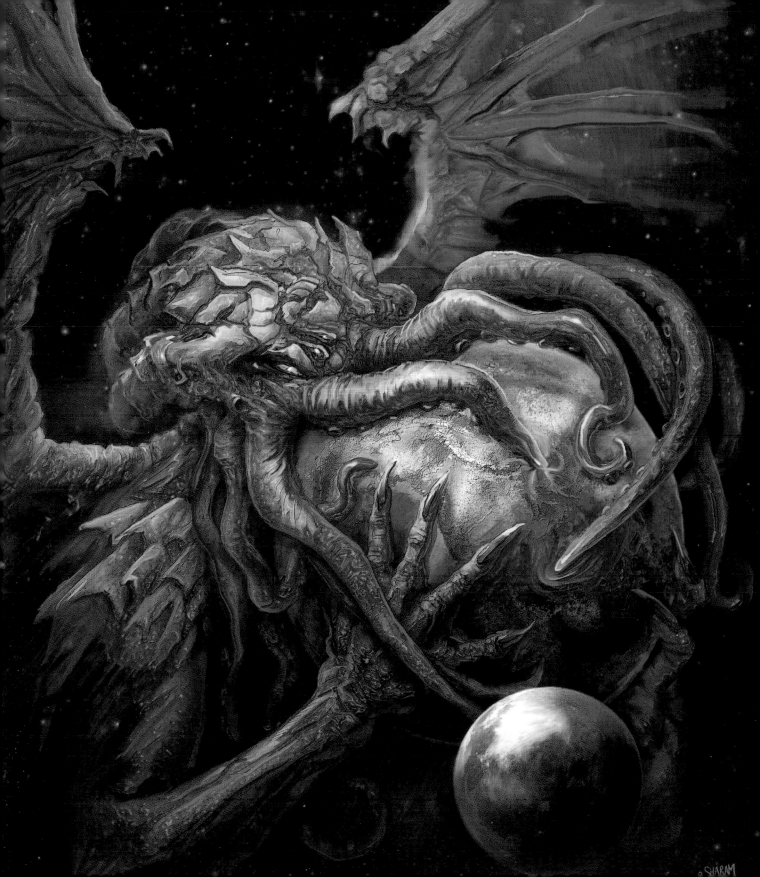

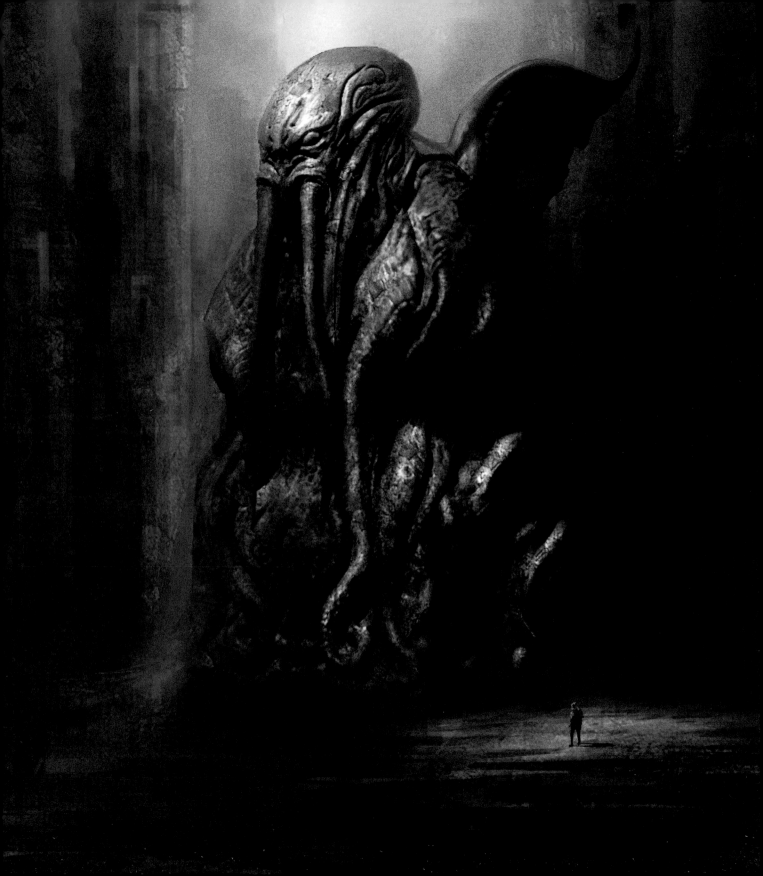

area of the Pacific. Thurston travels to Norway to learn that Johansen has suddenly died following an encounter with 'two Lascar sailors'.

However, Johansen's wife gives Thurston a manuscript that reveals what actually happened on the unknown island. In the manuscript Johansen describes the city they found there, the 'nightmare corpse-city of R'lyeh' and a portal they opened that accidentally released Cthulhu from imprisonment. All but Johansen go mad and are killed by the monster. The tale ends with Thurston's dreadful realization that he is doomed. 'I know too much,' he says, 'and the cult still lives'.

So, What Exactly Is Cthulhu?

According to the Mythos, Cthulhu is one of the Great Old Ones, the ultra-powerful beings that dropped in on us from the stars millions of years ago. With his retinue, he constructed the great stone city of R'lyeh in the Pacific Ocean. War followed with the Elder Things, beings that had existed on Earth for millions of years prior to the arrival of the Great Old Ones but following the declaration of peace, the two sides agreed to co-exist.

Catastrophe!

It is not known exactly when or why it occurred (vengeance of rival gods, changes in the alignment of the stars... who knows?) but R'lyeh suddenly sank beneath the waves,

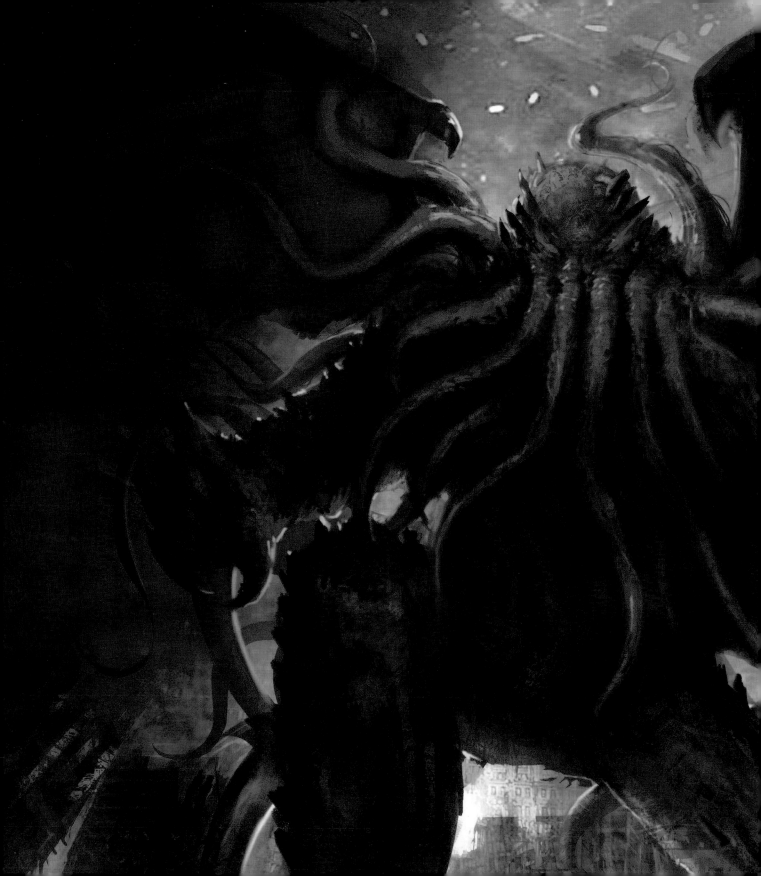

trapping Cthulhu, his family and his retinue. His telepathic signals could not make their way through the deep waters of the Pacific and he was able to contact followers only occasionally through dreams. Cthulhu was helpless, unable to break free from his watery prison until the stars realigned themselves or some other extraordinary set of circumstances occurred.

The Cult of Cthulhu

Communicating through dreams, Cthulhu was able to start laying the foundations of his cult amongst humans. Evidence of Cthulhu worship was found by the fictional Professor Angell in many locations – Haiti, Louisiana, the South Pacific, Mexico, Arabia, Siberia, K'n-yan (a fictional cavern beneath Oklahoma in the Cthulhu Mythos) and Greenland.

Bizarrely, however, there have been several real small cults that have been created in response to the Cthulhu Mythos, some of them mingling Lovecraftian 'philosophy' with other belief systems such as Satanism. Others accept that the universe of Cthulhu is purely fictional but subscribe to the ideas represented within it.

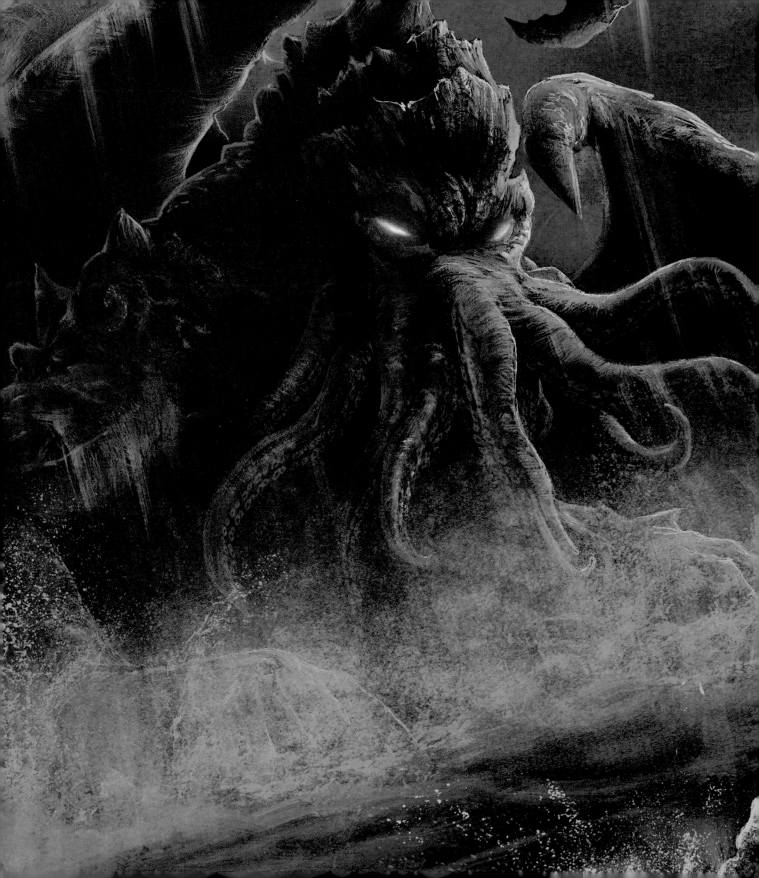

The Cthulhu Mythos

The term 'Cthulhu Mythos' to describe Lovecraft's universe was first coined by American writer and anthropologist August Derleth, who corresponded regularly with Lovecraft. Elements of the universe have been borrowed by other writers to explore and expand the Mythos in their stories. According to Lovecraft enthusiast Robert M. Price, the Cthulhu Mythos has two distinct stages. The first – the 'Cthulhu Mythos proper' as he terms it – was created and developed during H.P. Lovecraft's lifetime and was subject to his personal control and influence. The second was under the control of August Derleth.

Derleth, along with Donald Wandrei, established the Arkham House publishing company in 1939 specifically to publish Lovecraft's stories after his death. The first time Lovecraft's work enjoyed the dignity of being published in proper book form was when Arkham House put out ***The Outsiders and Others*** that year.

Yog Sothery

Depressingly, a major theme of Lovecraft's work is just how irrelevant we humans are in the face of the great cosmic mysteries and horrors of the universe – a.k.a. Cthulhu and the Great Old Ones.

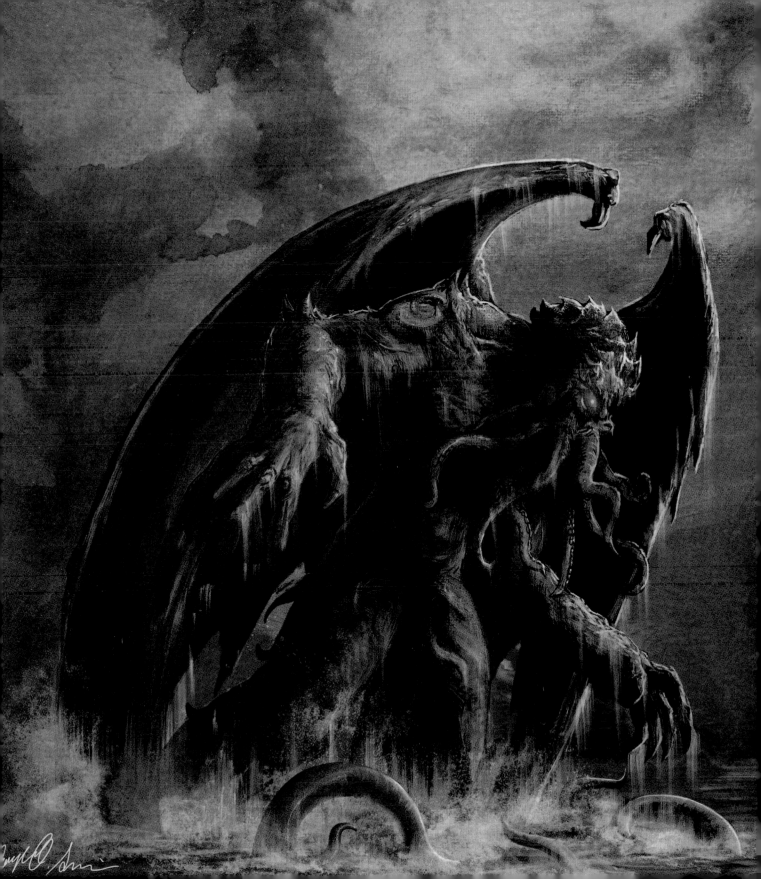

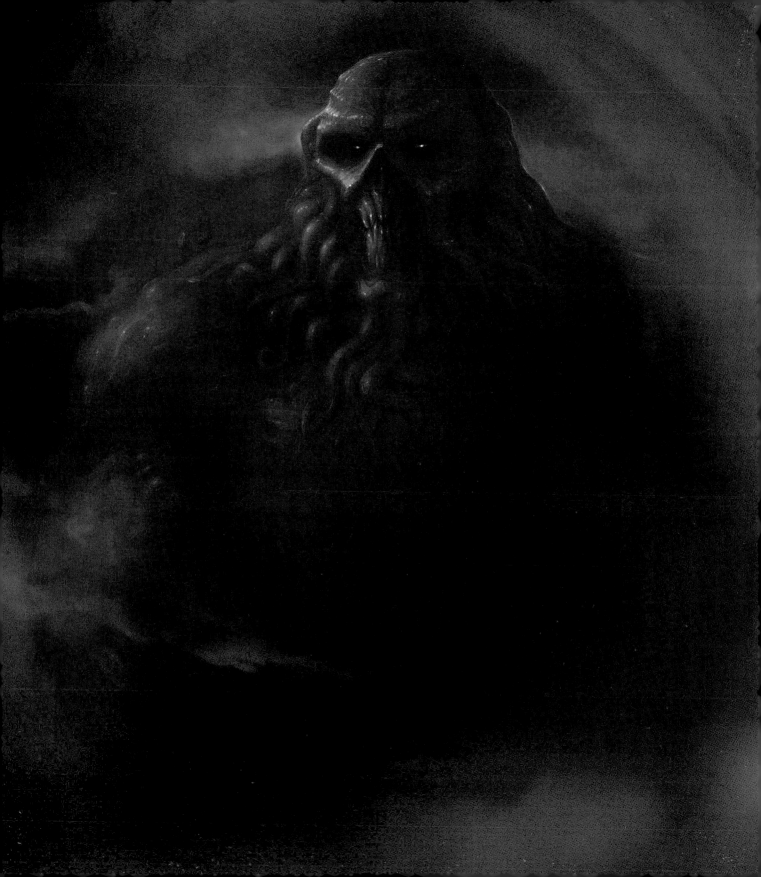

His universe is uncaring and our tiny minds can never take it in. However, some have claimed that Lovecraft had no intention of creating a mythological framework, as assembled by Derleth and others. Indeed Lovecraft, in a rather tongue-in-cheek manner, referred to his creation as 'Yog Sothery', and even found it necessary on occasion to remind readers that the universe he was creating was actually fictional!

The Derleth Mythos

Sometimes known as the Derleth Mythos, to distinguish it from when Lovecraft was alive, this stage features Derleth's systematization of the elements found in Lovecraft's work. However, many Lovecraft fans point out the dichotomy between Derleth's Christian point of view and Lovecraft's amoral universe. For Derleth there is always hope and he sees the Cthulhu Mythos as basically a struggle between good and evil. At least, however, Derleth's championing and publishing of Lovecraft's stories kept his work alive.

The Necronomicon

The **Necronomicon** is a book that features in several of Lovecraft's stories, first appearing in 1924's 'The Hound'. It also makes appearances in works by Derleth and Clark Ashton Smith. Supposedly written by the 'Mad Arab', Abdul Alhazred, the book was said to contain, amongst other things, the history of the Great Old Ones and

Weird Tales, March 1944.

They shall soon rule where man rules now…They wait patient and potent, for here shall They reign again.'

H.P. Lovecraft,
'The Dunwich Horror'

instructions as to how they could be summoned. Of course, the **Necronomicon** is a purely fictional invention, as noted by Lovecraft in a letter to American broadcaster Willis Conover: 'Now about the 'terrible and forbidden books' – I am forced to say that most of them are purely imaginary. There never was any Abdul Alhazred or **Necronomicon**, for I invented these names myself'. That fact has failed, nonetheless, to prevent many readers of Lovecraft from besieging booksellers and librarians with requests for a copy.

Tales of the Cthulhu Mythos

The Mythos-style melange of myth, antiquity, science and celestial decadence can be found in a number of stories other than 'The Call of Cthulhu'. Lovecraft expert Lin Carter has listed the stories he believes are firmly fixed within the Cthulhu Mythos, and we have also added 'The Case of Charles Dexter Ward' which features chanting of Yog-Sothoth. So, if you think you are brave enough to venture into the Cthulhu Mythos, here are the stories you need:

The Nameless City

Published in 1921 in **The Wolverine** magazine, and considered to be the first Cthulhu Mythos story. Lovecraft claimed it was based on a dream inspired by the last line of Lord Dunsany's 'The Probable Adventure of the Three Literary Men' – 'the unreverberate blackness of the abyss'.

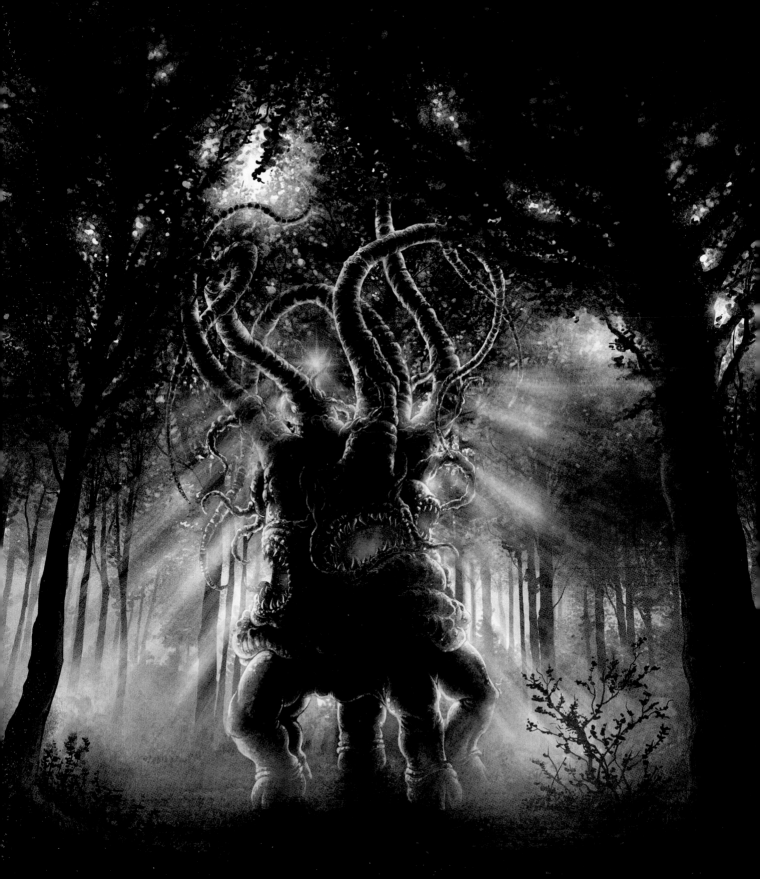

The Hound

Published in **Weird Tales** in 1924, a story about grave robbers that owes much to Edgar Allan Poe, containing the first mention of the **Necronomicon**. Dismissed by Lovecraft as 'a piece of junk'.

The Festival

Published in **Weird Tales** in 1925, and inspired by Lovecraft's first visit to Marblehead, Massachusetts, which he described as 'the most powerful single emotional climax experienced during my nearly forty years of existence'. The first story to be set in Lovecraft's scary fictional city, Arkham.

The Call of Cthulhu

Written in the summer of 1926 and published in **Weird Tales** in 1928.

The Case of Charles Dexter Ward

This short novel remained unpublished during Lovecraft's lifetime. Set in Providence, it features the first mention of the Cthulhu Mythos entity Yog-Sothoth, whose name is used in an incantation. The **Necronomicon** also features.

The Dunwich Horror

Published in a 1929 issue of **Weird Tales**, the story – something of a homage to Arthur Machen – takes place in another fictional Massachusetts town, Dunwich, located in the Miskatonic Valley.

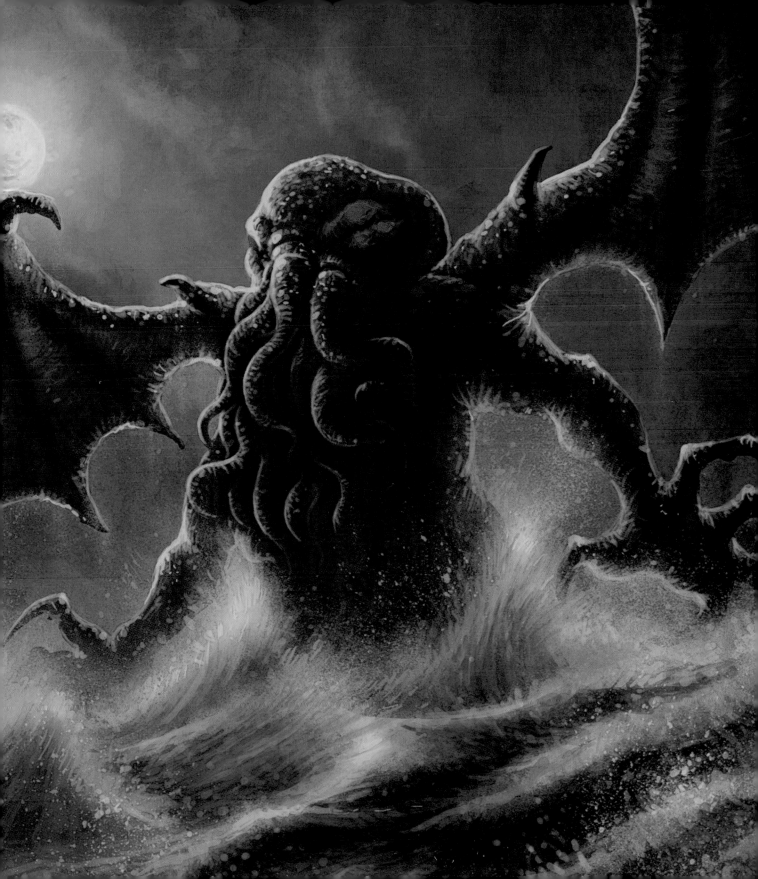

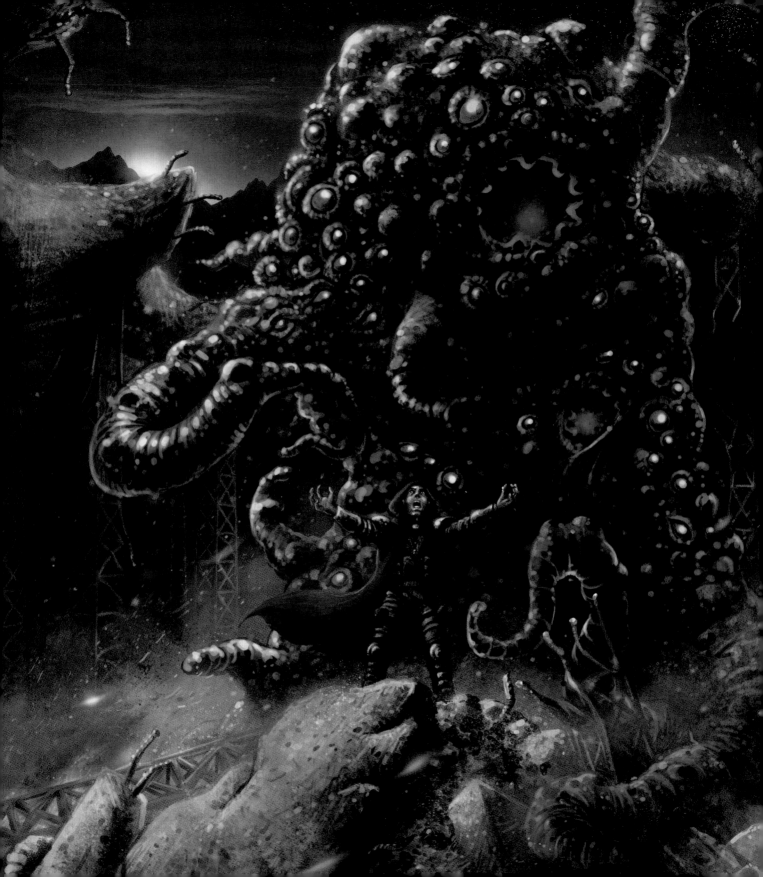

The Whisperer in the Darkness

Tending towards science fiction, this tale introducing the Mi-Go, an extraterrestrial race of fungoid creatures, was published in *Weird Tales* in 1931.

The Dreams in the Witch House

Probably inspired by a lecture that Lovecraft attended: *The Size of the Universe*, given by Dutch astronomer Willem de Sitter, this story of witches and Elder Things was published in *Weird Tales* in 1933.

At The Mountains of Madness

Rejected by *Weird Tales* because of its length, this 1931 novella was serialized in 1936 in rival mag *Astounding Stories*. It tells the story of an expedition to Antarctica, (Lovecraft was fascinated by Antarctic exploration), that uncovers a huge abandoned city and life forms unknown to science, such as Shoggoths.

The Shadow Over Innsmouth

Another novella by Lovecraft, set in New England and dealing with degeneration and mysteries beyond human understanding. Written in 1931 and rejected twice by *Weird Tales*, it was published in 1936 as a bound booklet, the only instance in his lifetime of his work being published other than in a periodical.

The Shadow Out of Time

Published in *Astounding Stories* in 1936, this story tells of the Great Race of Yith who can travel through space and

At the
Mountains of Madness
H. P. Lovecraft

The Genius of Gothic Horror 451

time and have built a huge library city filled with the past and future history of many races, including humans. Although praised by many, Lovecraft was so dissatisfied with it that he neglected to keep a copy when he mailed it to the magazine.

The Haunter of the Dark

Written by Lovecraft as a sequel to 'The Shambler of the Stars' by Robert Bloch, this tale first saw the light of day in a 1936 issue of **Weird Tales**. In 1950, Bloch wrote a third story in the sequence, 'The Shadow from the Steeple'.

The Thing on the Doorstep

A story of possession and murder, written in 1933, and first published in the January 1937 edition of **Weird Tales**, two months before Lovecraft's death.

History of the Necronomicon

Written in 1927 and published in 1938, a short story describing the **Necronomicon**.

Fungi from Yuggoth

A sequence of 36 sonnets about realities beyond the everyday, ancient knowledge and nightmare beings, mostly written between 27 December 1929 and 4 January 1930. The entire collection was published in **Beyond the Wall of Sleep** by Arkham House in 1943.

'Grunt, bark, or cough the imperfectly formed syllables Cluh-Luh with the tip of the tongue firmly affixed to the roof of the mouth. That is, if one is a human being. Directions for other entities are naturally different.'

H.P. Lovecraft, on pronouncing Cthulhu

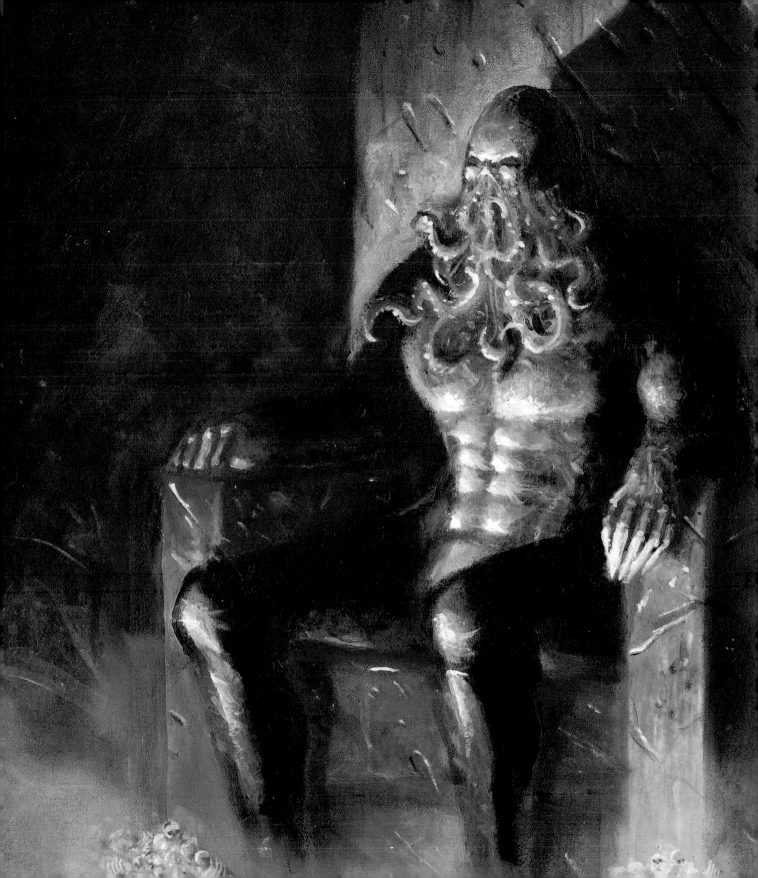

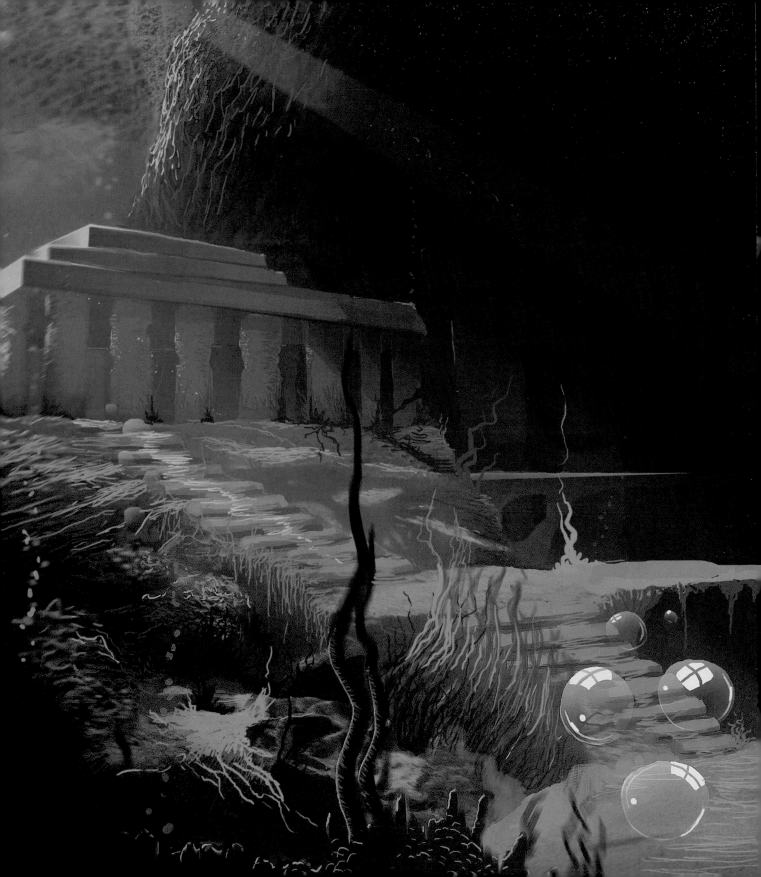

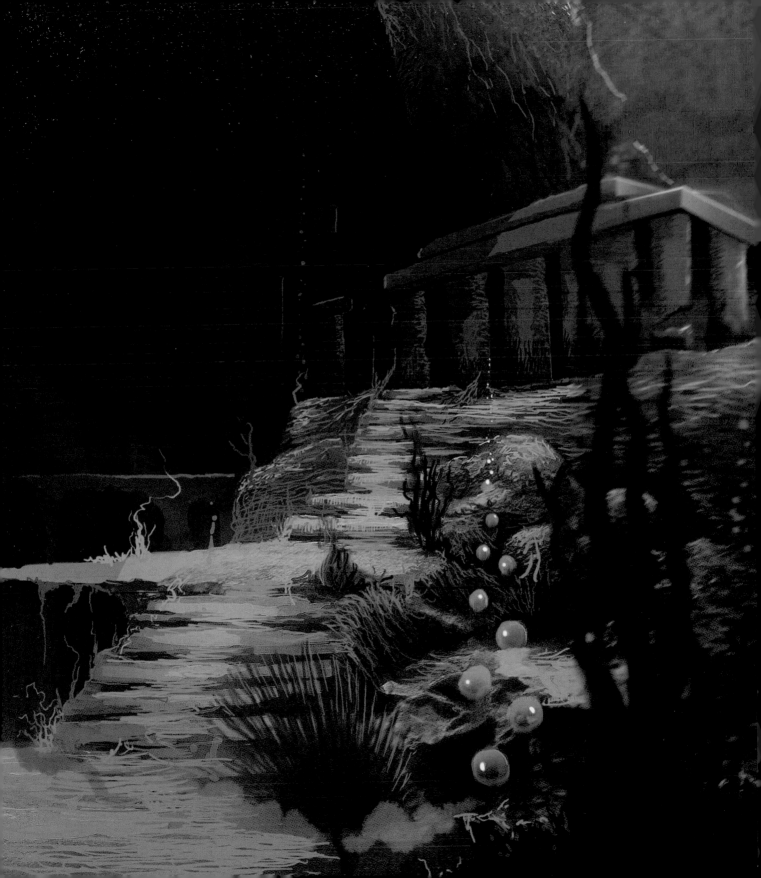

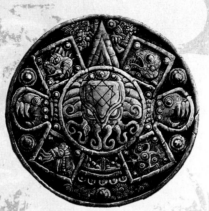

Horror Stories

Lovecraft encouraged his friends and associates to beg, borrow and steal ideas, themes, locations and characters from his work and he did the same to them – the toad-god Tsathoggua, for instance, that he lifted from his friend Clark Ashton Smith. But, there is little doubt that Mythos fiction hit a low point following August Derleth's demise. Writers produced lazy, clichéd stories that used the names, but failed miserably to create the real atmosphere of the Cthulhu universe. Thanks to the efforts of Arkham House and some great magazine editors, the cosmic awe and terror returned towards the end of the last century and the beginning of this one. Some big names have had a go, too.

The Confessions of Cthulhu

English author Neil Gaiman is one of the world's best-loved authors, famous for the comic book series ***The Sandman*** and novels such as ***Coraline***. An avid fan of Lovecraft and the Cthulhu Mythos, he has turned his hand to some Lovecraftian stories that are worth searching out, such as 'A Study in Emerald', a pastiche of the Sherlock Holmes story 'A Study in Scarlet', which he wittily transfers to the Cthulhu Mythos. He has also penned the wonderfully titled 'I Cthulhu or What's a Tentacle-faced Thing Like Me Doing In a Sunken City Like This' in which the monster

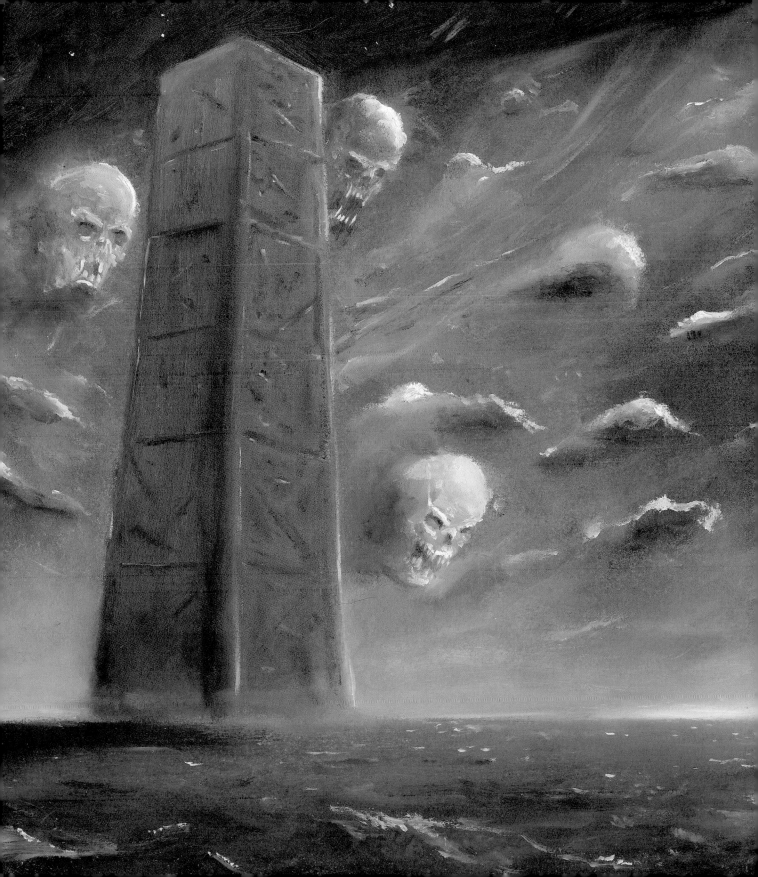

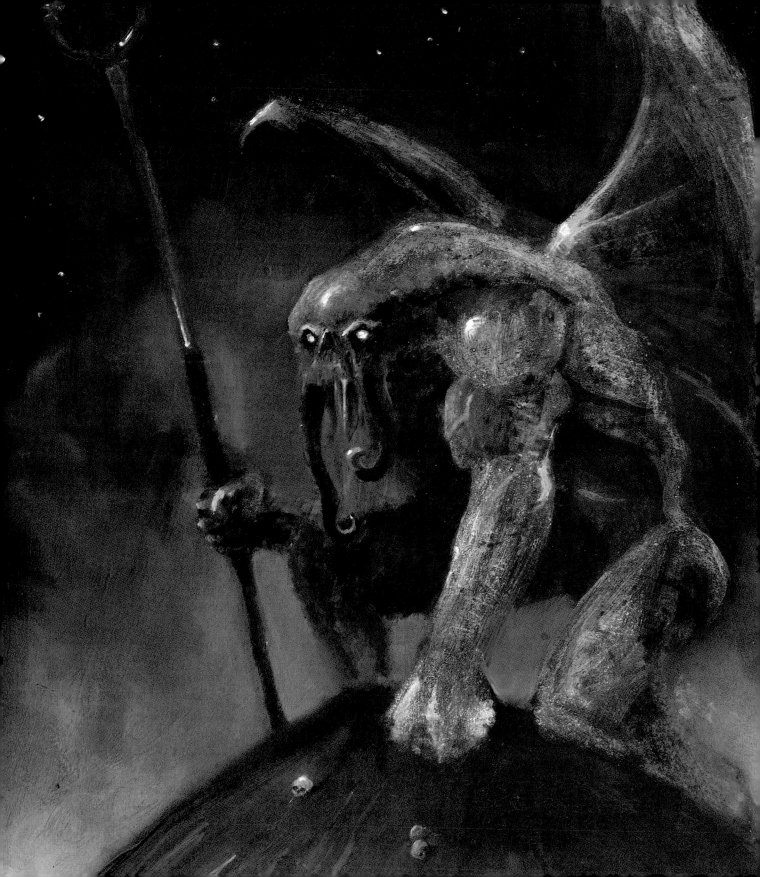

dictates his life story to a man called 'Whateley', a reference to 'The Dunwich Horror'.

Here Come the Tcho-Tcho

The master storyteller Stephen King (**Carrie**, **The Green Mile**, **The Shining** et al) has also turned his hand to a Cthulhu Mythos tale, the short story **Crouch End**, to be found in the collection **New Tales of the Cthulhu Mythos**, published by Arkham House in 1980. That anthology also contains stories by other Cthulhu writers such as Ramsey Campbell, Brian Lumley and Frank Belknap Long. American horror writer T.E.D. Klein contributed 'Black Man with a Horn', described by Lovecraft expert and critic S.T. Joshi as demonstrating 'a deep understanding of the psychological effects of horror'.

It is a fascinating story, incestuously featuring an author modeled on Lovecraft circle member Frank Belknap Long, who becomes involved with a missionary who is fleeing the 'Chaucha', a creature he encountered in Malaysia. The author learns later that the Chaucha is actually the Tcho-Tcho which he had until then believed to have been merely a fictional construct of his friend, H.P. Lovecraft. The author-narrator begins to be threatened by the being that is worshipped by the Tcho-Tcho – a terrifying black, half-fish, half-human demon with a horn on its face. It is a wonderful play on the fictional nature of Lovecraft's creations.

'Yog-Sothoth is the gate. Yog-Sothoth is the key and guardian of the gate. Past, present, future, all are one in Yog-Sothoth.'

H.P. Lovecraft, 'The Dunwich Horror'

Starting Young

Born in Liverpool in England, Ramsey Campbell is one of the foremost horror writers of his generation, 'every bit the equal of Lovecraft' according to S.T. Joshi. Campbell discovered Lovecraft at an early age and was first published aged just 16 by Arkham House with the story 'The Church in the High Street'. A couple of years later his collection of Lovecraft-inspired tales, **The Inhabitant of the Lake and Less Welcome Tenants**, was also published by Arkham.

Mexicans and Transvestites

Also adding to the Cthulhu Mythos are modern writers such as the Mexican Luis G. Abbadie. He is considered an expert on the **Necronomicon**, and has written **El Necronomicon: un comentario**, a summation of his work, including Cthulhu Mythos stories. 2012 saw the publication of his novel, **2012: El codigo secreto del Necronomicon**. American writer and illustrator Gary Myers has written several books in the Cthulhu Mythos genre. His collection **Dark Wisdom**, published in 2007, locates the stories in a contemporary setting.

Other authors expanding the Mythos include fascinating Seattle-based transvestite and self-styled 'Queen of Eldritch Horror' W. H. Pugmire. He has made a major contribution to the Mythos in the creation of the Sesqua Valley, a fictional location for weird skulduggery in the American Pacific Northwest. British author David J. Rodger's

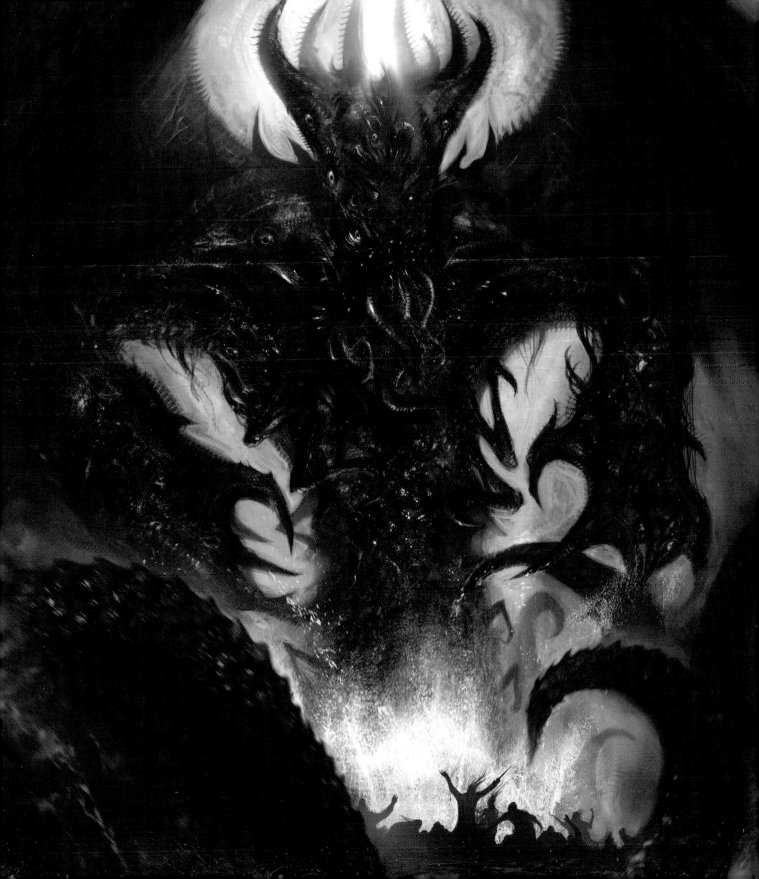

take on the Mythos is also worth checking out. He has created a heady mash-up with high-tech intrigue and/or political or corporate shenanigans. He created several new Old Ones in his novels **Edge**, **Dog Eat Dog** and **Living in Flames**.

Call the Doctor

If you're a fan of Doctor Who and Sherlock Holmes, this piece of fiction by Andy Lane brings both elements together and throws in a healthy dose of the Cthulhu Mythos for good measure. The Seventh Doctor teams up with Sherlock and Dr Watson to investigate mysterious goings-on on a planet called R'lyeh. Not only does Azathoth make an appearance, but other already-known Doctor Who monsters are equated with beings from the Mythos.

Check the Contents

There are, of course, numerous anthologies bringing together Cthulhu Mythos stories, but buyer beware – due to its increasing popularity there is a growing number of anthologies out there, and some are worth more attention than others. One of the best of the recent collections is the deeply unsettling **New Cthulhu: the Recent Weird**, published in 2011 and featuring Neil Gaiman, Caitlin R. Kiernan, Sarah Monette, Kim Newman, China Miéville, Cherie Priest, Michael Marshall Smith, David Barr Kirtley, Lon Prater and Charles Stross.

'Who knows the end? What has risen may sink, and what has sunk may rise. Loathsomeness waits and dreams in the deep, and decay spreads over the tottering cities of men.'

H.P. Lovecraft, 'The Call of Cthulhu'

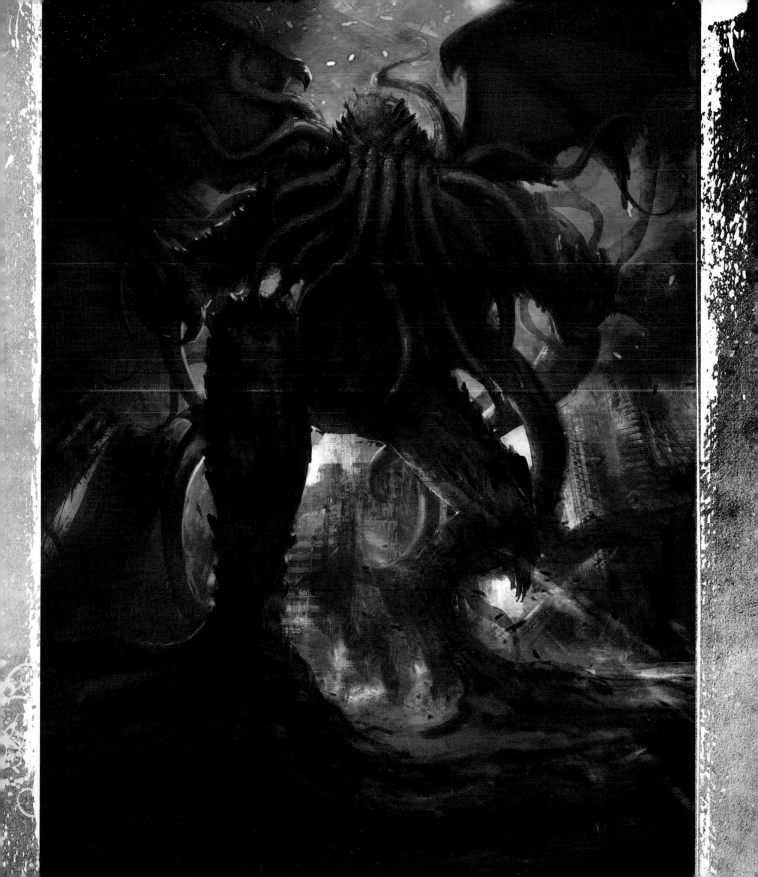

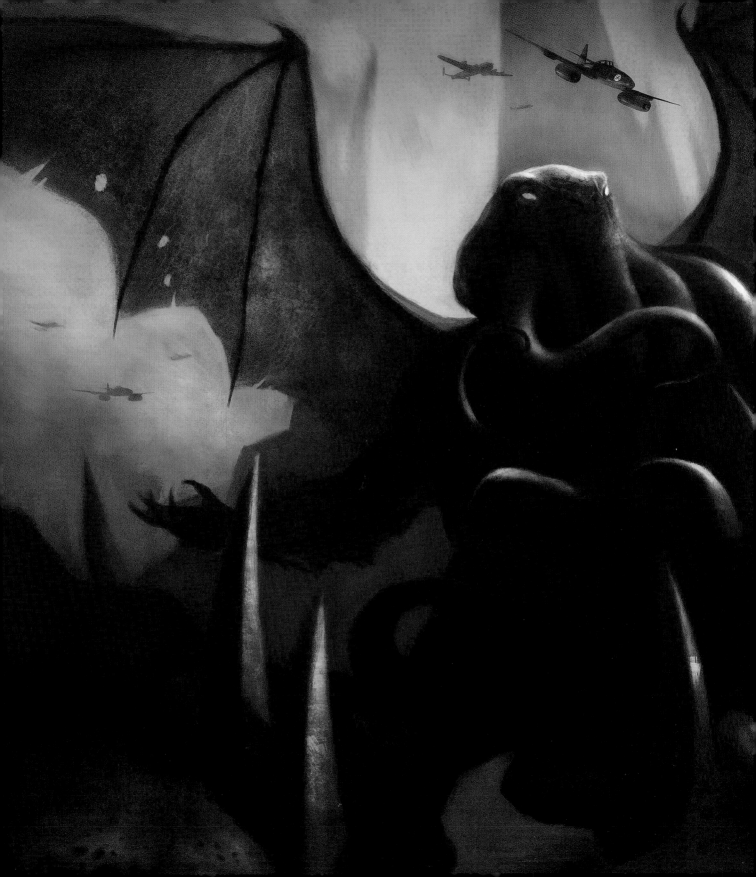

Also highly recommended to give you a true Lovecraftian chill down your spine is 1999's **Cthulhu 2000**, brilliant modern-day Cthulhu Mythos story-telling by the likes of Poppy Z. Brite, Bruce Sterling and Michael Shea.

By the way, if you are trying to make sense of the Cthulhu universe of complex names and strange interconnections, get your hands on a copy of Daniel Harms' **The Cthulhu Mythos Encyclopedia**. If you happen to bump into a bat-winged, octopus-headed creature, this indispensable Cthulhu Mythos reference work will point you in the direction (probably the nearest exit!).

Further Reading

There are hundreds of books in the Cthulhu Mythos style, far too many to list here. You can seek them out in Chris Jarocha-Ernst's **A Cthulhu Mythos Bibliography and Concordance**, listing a phenomenal 2,620 items of Mythos or Mythos-related fiction and poetry, from Ambrose Bierce, Arthur Machen and Algernon Blackwood to the writers of the late 1990s. The **Concordance** section lets you cross-reference things. If you have a burning desire to know which stories the Mi-Go have featured in, look no further.

'The Old Ones were, the Old Ones are, and the Old Ones shall be. Not in the spaces we know, but between them, They walk serene and primal, undimensioned and to us unseen.'

H.P. Lovecraft, 'The Dunwich Horror'

'Cthulhu fhtagn'

H.P. Lovecraft, 'The Call of Cthulhu'

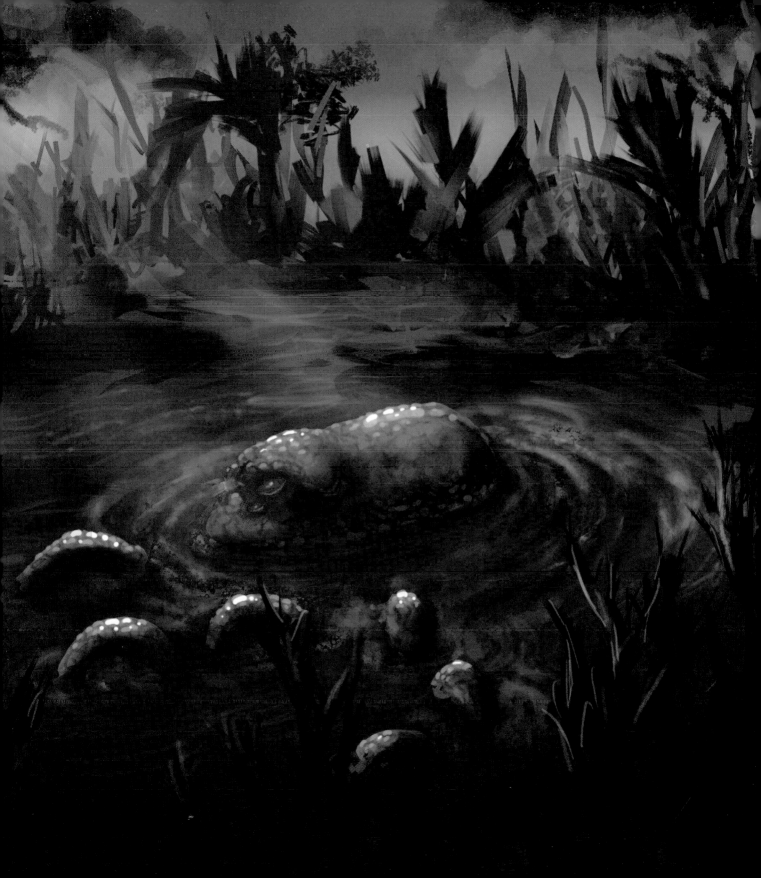

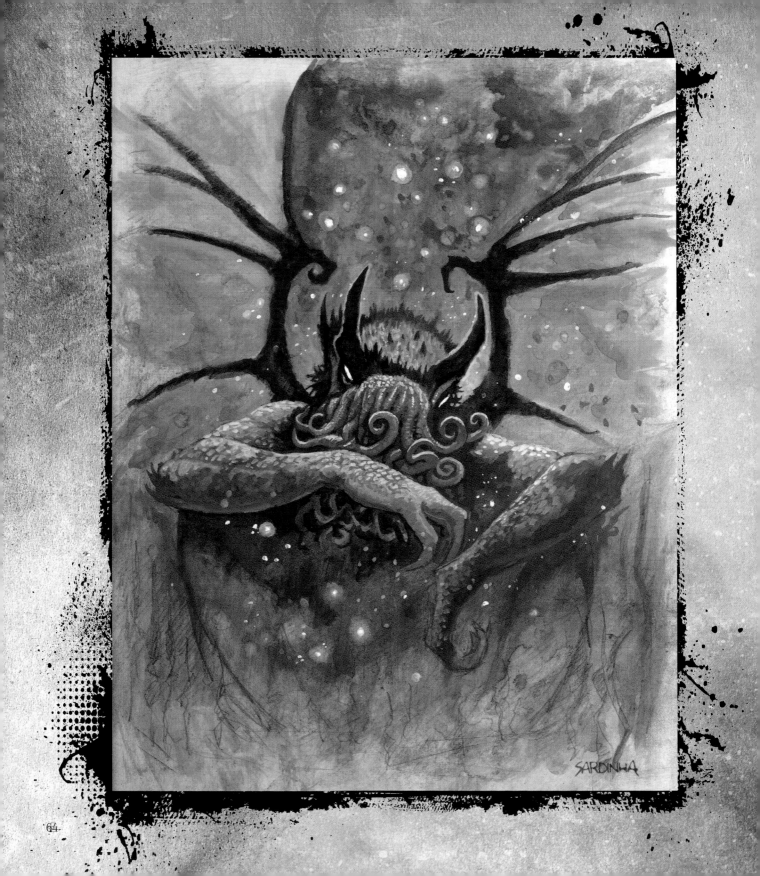

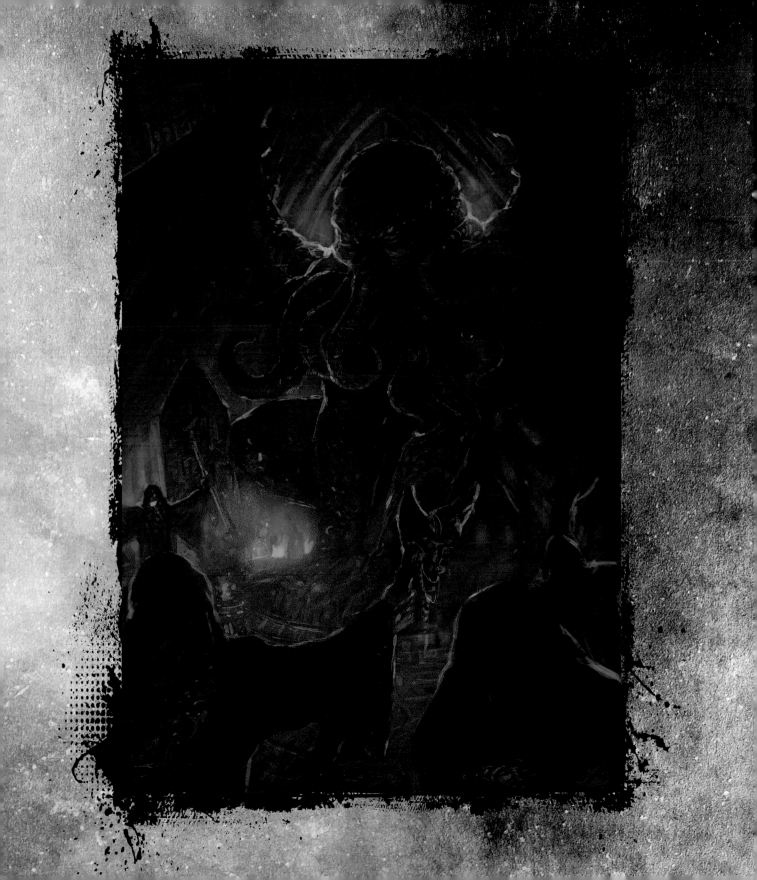

Cthulhu On-Screen

It is astonishing the impact that Cthulhu has had, especially when you realize that he does not show his ugly, tentacled face very often in Lovecraft stories.
Perhaps we love him because he is close to us, imprisoned as he is in one of our oceans and, therefore, just that bit too accessible. But he also taps into something almost indescribable – the primal senses of horror, fear and disgust that we push to the recesses of our minds in order to evade their slimy clutches. He is always out there, waiting, and knowing that we are terrified out of our skins by the prospect of him breaking out and arriving on our very own doorstep.

I'm Ready for my Close-up, Mr Cthulhu

Of course, the cinema screen is the perfect vehicle for Cthulhu thrills and it is to be hoped that with digital effect technology improving by the minute, more Cthulhu Mythos movies might be on the cards. Lovecraft fans were highly excited by one particular film being made by ace director J.J. Abrams. **Cloverfield** features a gigantic monster attacking New York and Cthulhu enthusiasts were convinced prior to release that the monster was going to be Cthulhu. Abrams burst their bubble, however, when he

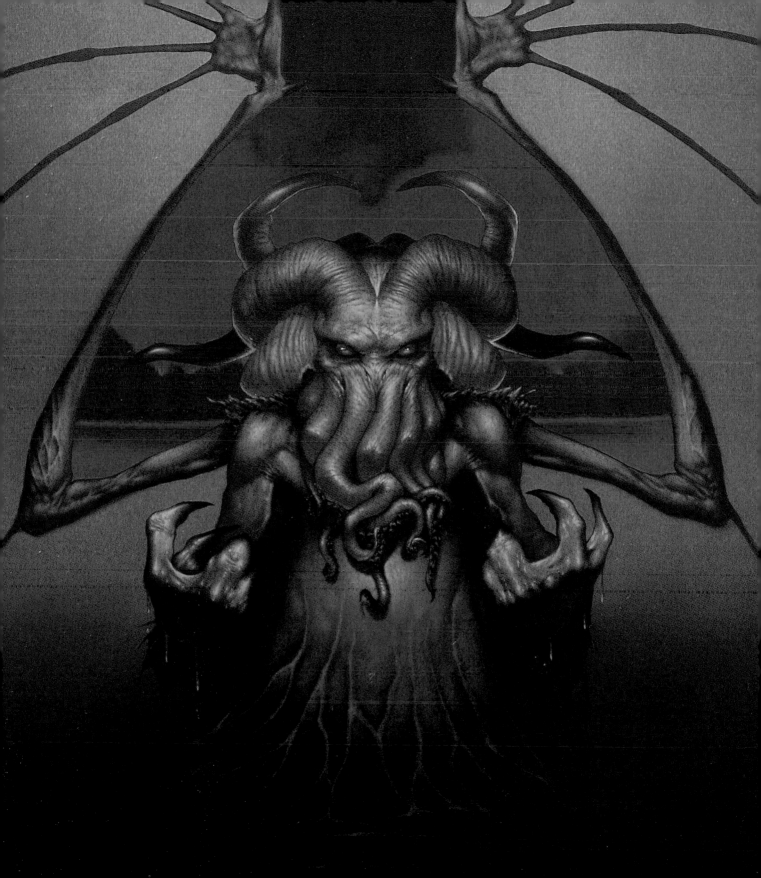

announced that the monster was a creature of his own devising, created especially for the film.

But Cthulhu does stalk movie culture now and then, as evidenced by the attractively writhing Cthulhu-style tentacles on the face of Davy Jones, played by the inimitable Bill Nighy, in the second and third Pirates of the Caribbean movies. And there have been a number of movies relating to the Cthulhu Mythos, some of which are not bad while others would make even the great Cthulhu – not a creature noted for his discerning taste – choke on his popcorn.

B-Movie Hell

If ever there was a director born to make a Cthulhu film it was Roger Corman, the master of the low-budget B-movie. In 1963 he helmed **The Haunted Palace**, a film that confusingly has a title borrowed from an Edgar Allan Poe poem, but is actually based on Lovecraft's **The Case of Charles Dexter Ward**. Unfortunately, even Vincent Price and Lon Chaney Jr. fail to excite. Another veteran horror movie actor, Boris Karloff, also fell victim to a mediocre script two years later in **Monster of Terror** (American title **Die, Monster, Die**), based on Lovecraft's 'The Color Out of Space'. Karloff also starred alongside Christopher Lee in **The Curse of the Crimson Altar** of 1968, based on 'The Dreams in the Witch House', although Lovecraft's name is mysteriously missing from the credits. It is notable for being Karloff's last film, if not much else.

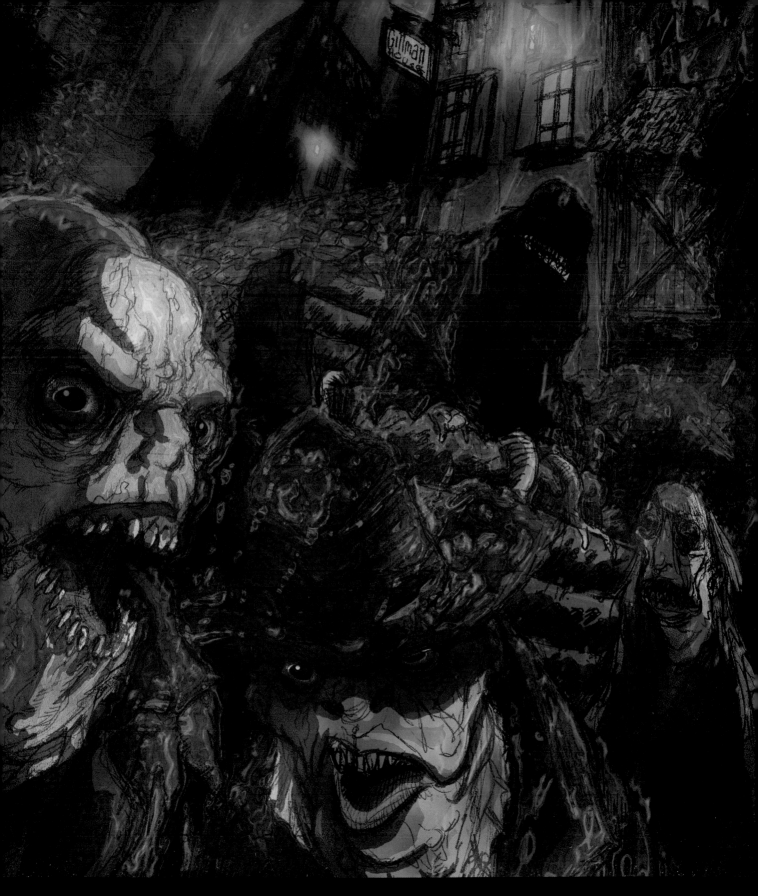

> *'Were we in the same nightmare? I mean, didn't we all just nearly get eaten by an…an It?'*

Buford 'Bubba' Brownlee, From Beyond

Although much of 'The Dunwich Horror' storyline was left intact in the film of the same name starring Dean Stockwell, the wholesome Sandra Dee and Ed Begley, making his last film; once again celluloid justice was not done to the Cthulhu Mythos, especially by the psychedelic visual effects that fail embarrassingly to capture the *zeitgeist*.

Locked in a Cellar…It Should Have Been

The Case of Charles Dexter Ward once again provides the background to 1992's **The Resurrected** (also called **Shatterbrain**), directed by Dan O'Bannon who, having written the script for **Alien**, knew a thing or two about monsters. At last this was a movie that stayed faithful to Lovecraft's original work. Sadly, the same cannot be said of 1993's **Necronomicon: Book of the Dead**, featuring three Lovecraft stories – 'The Rats in the Walls', 'Cool Air' and 'The Whisperer in the Darkness'. One of its stars was habitual Lovecraftian actor Jeffrey Combs, who has starred in no fewer than eight Lovecraft adaptations. A character named Lovecraft finds a copy of the **Necronomicon** in a monastery and, locked in a cellar, begins to read it. It was a shame the film didn't suffer a similar fate.

Humans Are Such Easy Prey

The 1986 movie **From Beyond**, with the poster legend 'Humans are such easy prey', was directed by Stuart Gordon, who was interested in making a series of Lovecraft

'In ten years, maybe less, the human race will just be a bedtime story for their children. A myth, nothing more.'

John Trent, In the Mouth of Madness

films using the same cast and crew, as Roger Corman had done on his Edgar Allan Poe adaptations. Although this never really came to pass, Gordon went on to direct three further Lovecraft projects.

Re-location, Re-location, Re-location

The Lovecraft/Cthulhu Mythos movies now began to come thick and fast. **The Curse** (1987) once again referenced Lovecraft's 'The Color Out of Space' but inexplicably moved the action to Tellico Plains, Tennessee from Arkham. Nor did the cast inspire much hope – a feeling that the film confirmed. A year later, **The Unnamable** employed that staple of the horror film – a bunch of kids staying overnight in a 'haunted house'. The **Necronomicon** features, and there are several Lovecraftian references, but the film bares little resemblance to Lovecraft's 1923 story.

Apocalypse Trilogy

A great director – John Carpenter (**Halloween**, **Assault on Precinct 13**, **Eyes of Laura Mars**), and a stellar cast (Sam Neill, David Warner, Charlton Heston), made the 1995 movie **In the Mouth of Madness**, the third in what is known as Carpenter's **Apocalypse Trilogy** (alongside **The Thing** and **Prince of Darkness**). Although it failed financially, it has achieved cult status over the ensuing years.

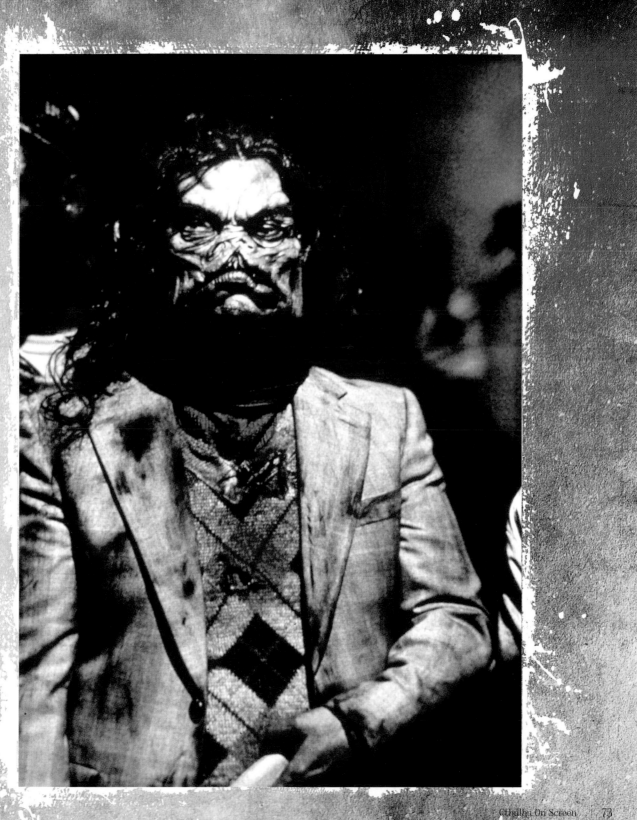

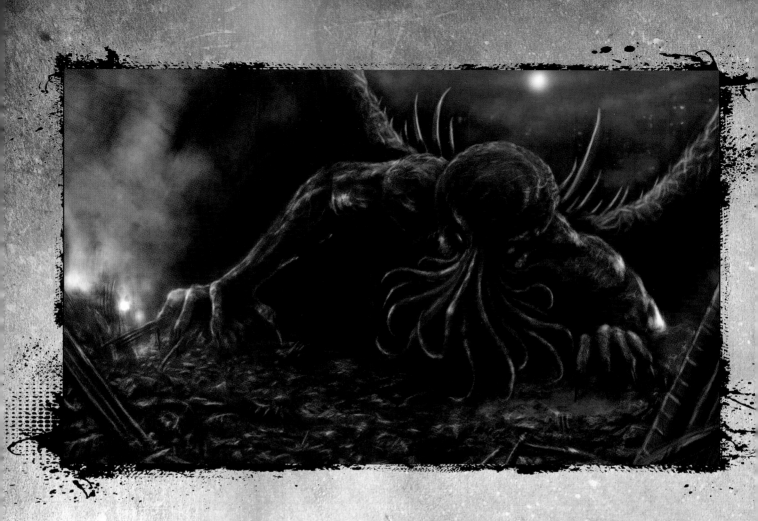

Straight to Video

Cthulhu must have been delighted to at last get his name on a movie poster in 2000 with the Australian low-budget movie **Cthulhu**, based on 'The Thing on the Doorstep' and 'The Shadow Over Innsmouth'. Sadly, there was little need for our favourite monster to dust off his tux for the awards season as the film went straight to DVD.

Another Dead Film Star

Stuart Gordon retuned to Lovecraft in his 2001 Spanish film, **Dagon**, based on 'The Shadow Over Innsmouth' rather than 'Dagon'. Unfortunately, it was not well received, one paper describing it as 'horror so extreme that it borders on camp'. Bizarrely, it was the third instance of a Lovecraft film being the last performance for one of its stars. Spanish film star Francisco Rabal joined Boris Karloff and Ed Begley in that particular pantheon, dying during an aeroplane flight not long after the wrap.

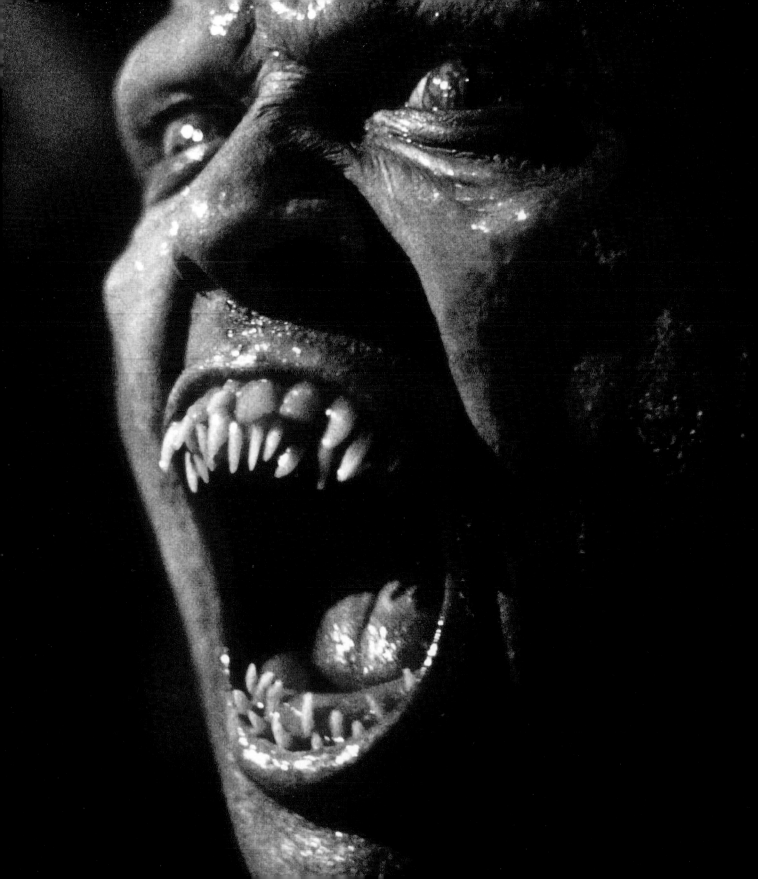

A Silent Film

Believed for many years to be unfilmable, **The Call of Cthulhu** finally made it onto film in 2005, when Sean Branney and Andrew Leman produced a silent, short, black and white version of the story that was distributed by the H.P. Lovecraft Historical Society. Blending vintage and modern film techniques, it has the feel of a film made in the 1920s and sticks pretty rigorously to the original story. It is undoubtedly the most successful film presentation of a Lovecraft story to date and was extremely well received by critics. The Lovecraft Society was also behind the 2011 film **The Whisperer in the Darkness**, again made by Brannan and Leman. It has the look and feel of a classic 1930s horror film and once again received critical plaudits, being described by the website Salon.com as having 'a chiller-diller conclusion and some moments of real terror.'

2007's **Cthulhu**, based on 'The Shadow Over Innsmouth', features a gay protagonist returning to his hometown where his father leads a New Age cult. Horror ensues in what is a creepy, atmospheric film made on a tight budget.

Get Kraken

Perhaps the most popularly-seen influence of Cthulhu on the big screen is the character of Davy Jones in the Pirates of the Caribbean series. Davy Jones's strikingly terrifying appearance is that of a man with the head of an octopus – sound familiar? Whilst stories of terror of the

'Let no joyful voice be
heard! Let no man look
up at the sky with hope!
And let this day be cursed
by we who ready to
wake… the Kraken!'

Davy Jones,
Pirates of the Caribbean:
Dead Man's Chest

'Humans are such easy prey.'

Dr Edward Pretorius,
From Beyond

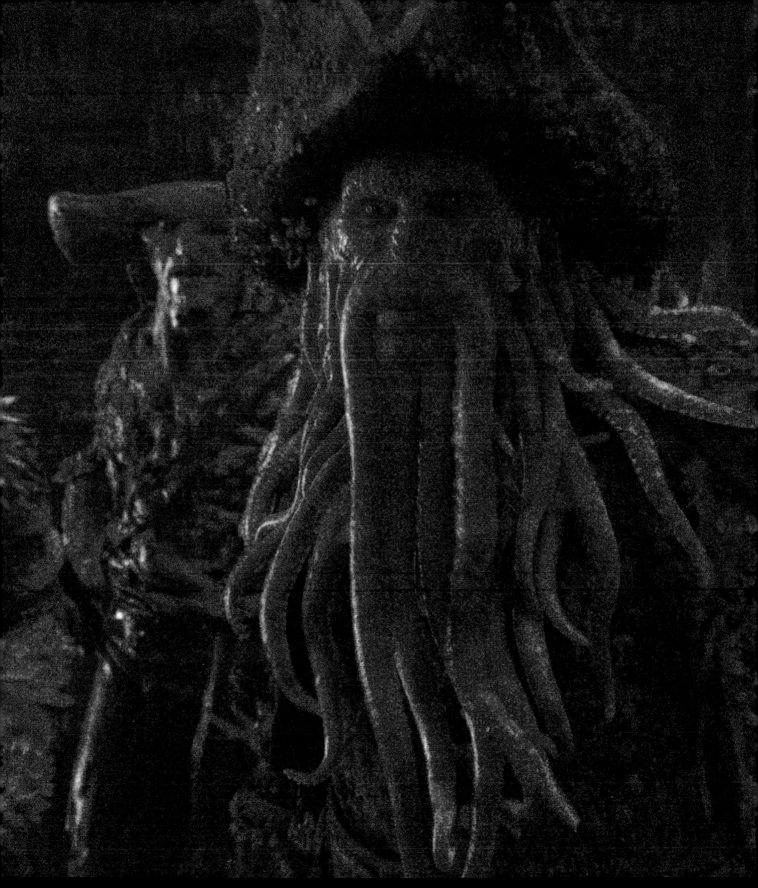

'The wheel has turned.
Yog-Sothoth knows the Gate.
That is the promise of the
Necromnomicon. Open the
Gate, let the Old Ones back in
and they will make you a god.'
Hackshaw, Cast a Deadly Spell

waves Davy Jones were told long before the time of Lovecraft, this particular interpretation of his physique, beard tentacles and all, surely takes some inspiration from Cthulhu.

Laugh?...I Almost Died of Fear

If, for some weird reason, you seek humour in your Cthulhu Mythos films, there is not a lot of choice, although some of the early Cthulhu movies are pretty laughable. In 2009, **The Last Lovecraft: Relic of Cthulhu** played the Great Old One for laughs, believe it or not. The lead character is the last descendant of H.P. Lovecraft and it features squid-like Deep Ones, Cthulhu's General Starspawn and crazed Cthulhu Cult followers.

Lovecraft, Gumshoe

In 1991, a bizarre Lovecraftian TV film appeared. Starring David Warner, Fred Ward and Julianne Moore, **Cast a Deadly Spell** represented a homage to all things Lovecraft. Ward is hard-boiled 1940s private detective Philip Lovecraft who lives in a fictional universe where everyone practises magic apart from him and where monsters and mythical beasts stalk the streets. The film references many elements of Lovecraft's work and the Mythos.

Three years later, it was re-worked as **Witch Hunt**, starring Dennis Hopper as Philip Lovecraft and set in the 1950s against the background of the Communist threat.

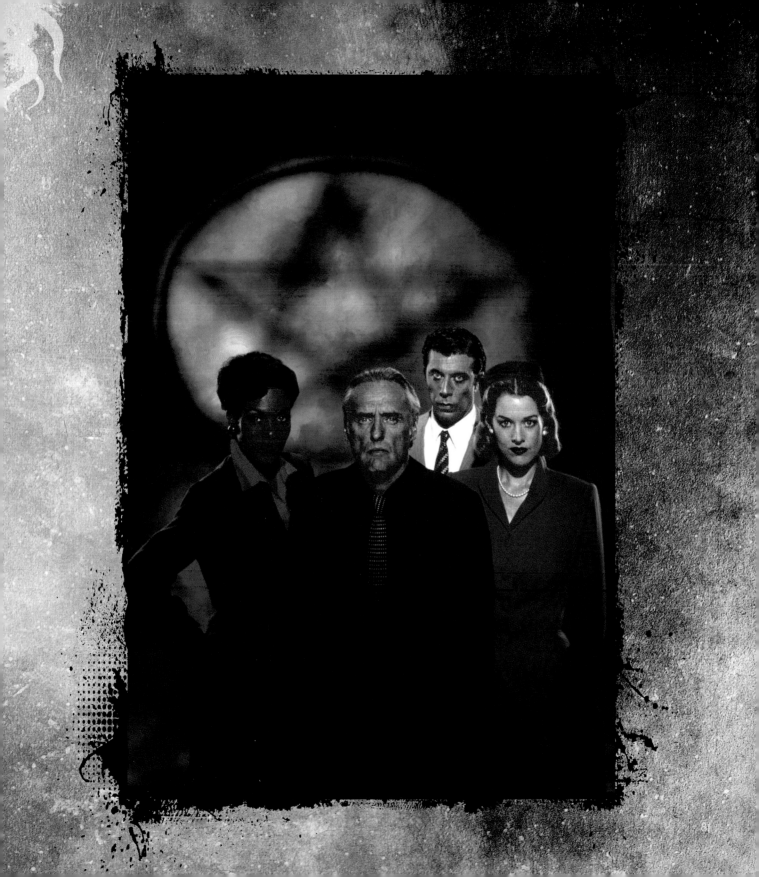

Cthulhu On the Box

Over the years, Cthulhu has not graced our television screens very often. The first occasion was probably 'Gramma' in 1985, a show in the **Twilight Zone** series taken from a short story by Stephen King, itself heavily indebted to Lovecraft's 'The Thing on the Doorstep'.

Who Ya Gonna Call...?

In 1987, the animated American TV series **The Real Ghostbusters** ran an episode entitled 'The Collect Call of Cthulhu'. It featured the **Necronomicon** being stolen from New York Public Library by the Cult of Cthulhu, who want to bring the great god back to life. Cthulhu rampages through Coney Island amusement park but is eventually neutralized by a charge of electricity and sent back to sleep.

Episodes of Fear

H.P. Lovecraft's Dreams in the Witch-House, directed by Lovecraftian director Stuart Gordon, hit television screens in 2005 as an episode of **Masters of Horror**. It was a slightly truncated version of the Lovecraft story, and although it is set in modern times it stays fairly faithful to the original.

In the sixth season of the American paranormal television drama series **Supernatural**, the episode 'Let It Bleed' features a manuscript allegedly written by H.P. Lovecraft

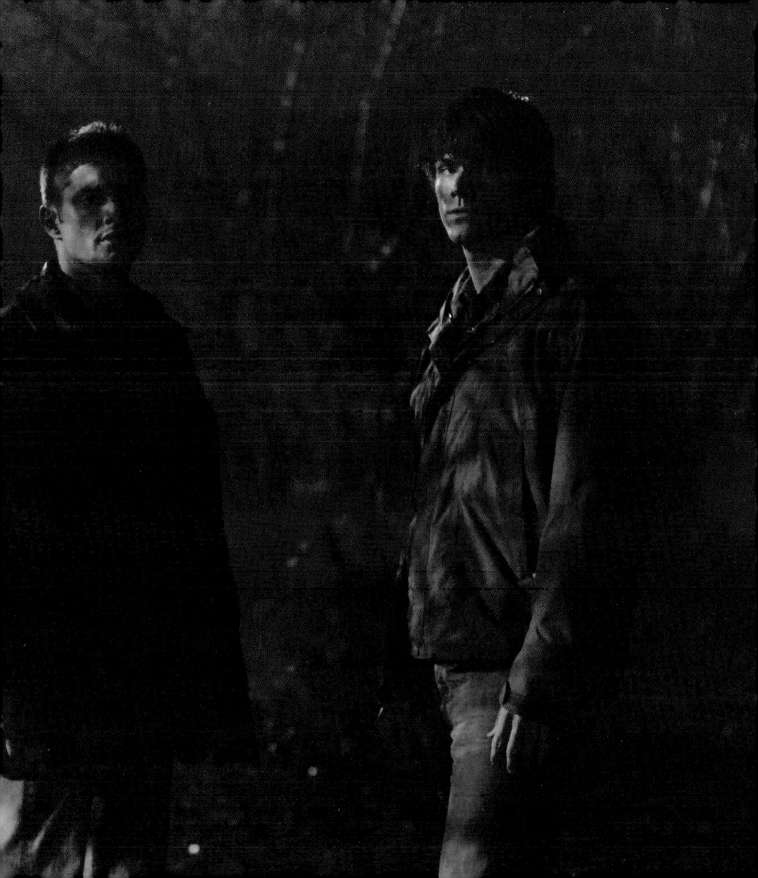

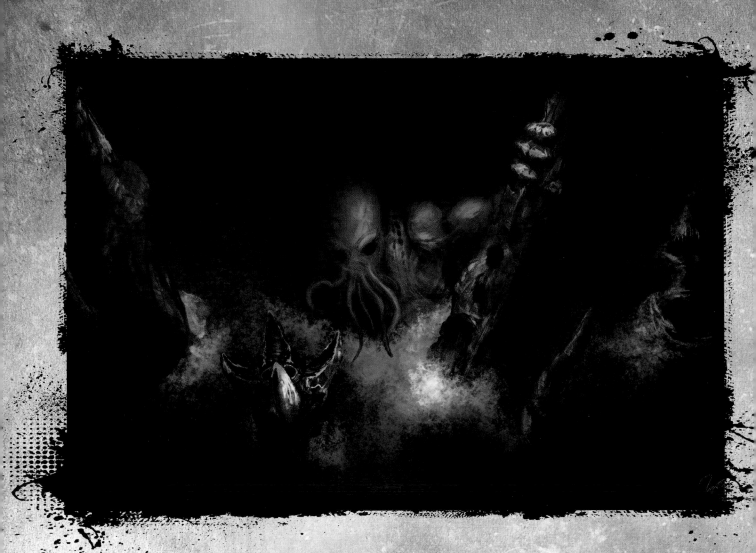

shortly before his death that describes Purgatory. Apparently, Lovecraft had invited guests to look into another dimension during a dinner party, as you do, and they all wound up dead or insane.

Cartoon Capers

Amazingly, Cthulhu has also featured on **South Park**, in no less than three episodes. In one of them, Cartman attempts to persuade Cthulhu to be his ally and he and Cthulhu go on the rampage, in the process massacring Justin Bieber and his fans. Eventually, they are defeated by Mint-Berry Crunch and Cthulhu is sent back to his world. An episode of **The Simpsons** also features Cthulhu. Titled **Cthulhu? Gesundheit**, our hero (Cthulhu, not Bart) emerges from a tap and Springfield is overrun by monsters.

Astonishing, but true.

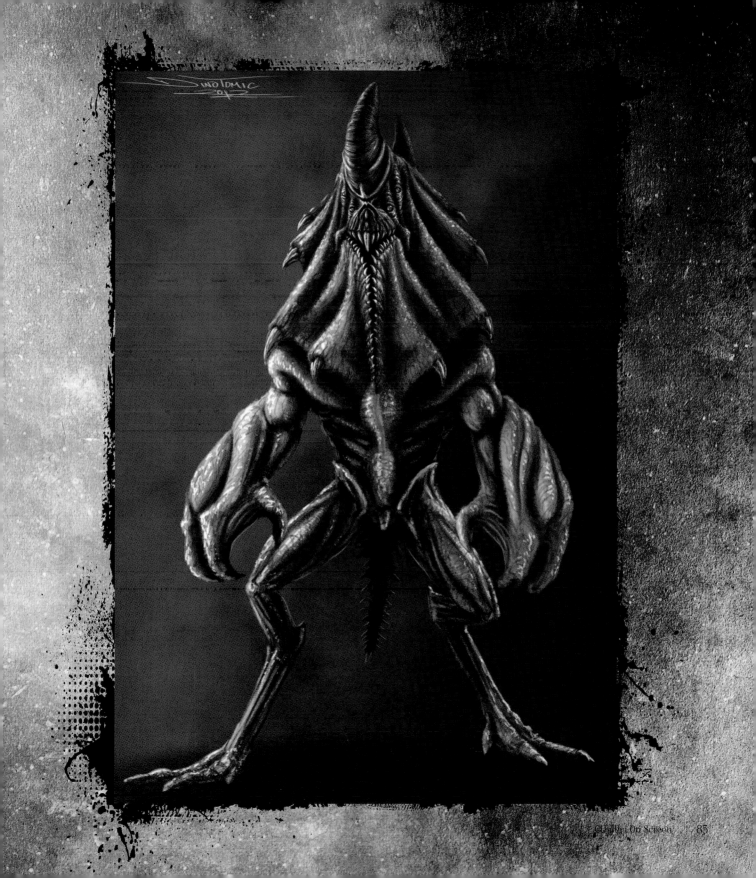

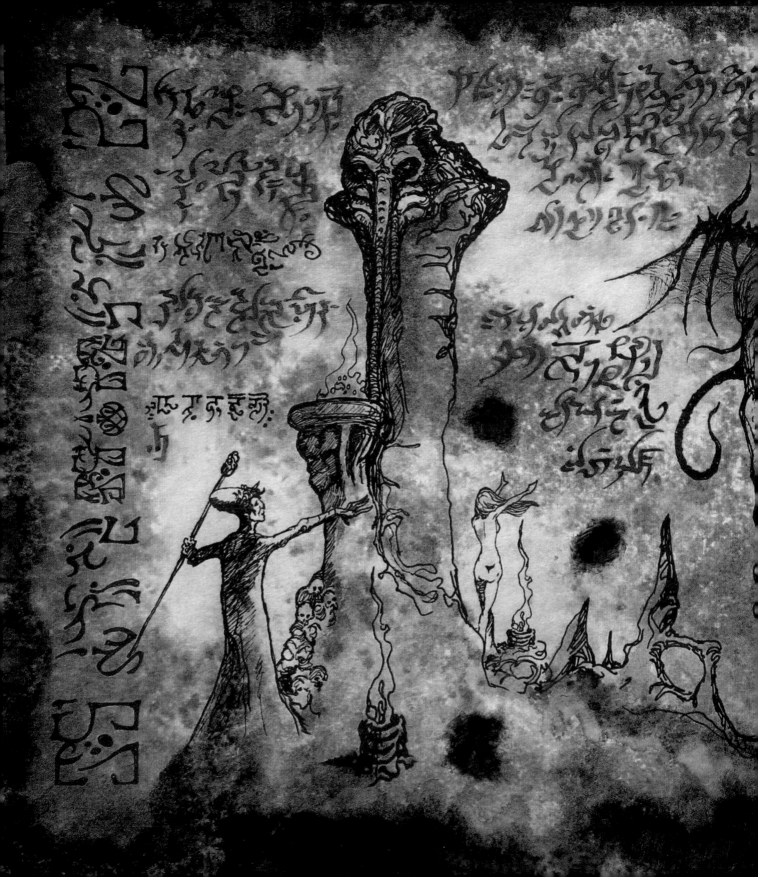

'You will go soon to a beautiful place. You will forget your world and your friends. There will be no time, no end...'

Uxia Cambarro, Dagon

'Lovecraft tried to jimmy a damn dimensional door. Idjit.'

Bobby Singer, Supernatural

Fun and Games

With its extravagantly grotesque characters and complex and sophisticated historical networks, the Cthulhu Mythos is tailor-made for games of all sorts, from interactive fiction to video games and from role-playing to card games.

Chaos Awaits

Chaosium Inc. is the publisher of the popular multi-award-winning Call of Cthulhu (popularly known as CoC), a role-playing game in which people take on the roles of characters from Lovecraft's stories.

They must unravel mysteries as they gradually realise the truth of Lovecraft's belief in the irrelevance of humanity in the great scheme of things; but, in a classic Lovecraftian way, the knowledge they gain inevitably threatens their sanity or kills them. It is an unsettling and challenging way to spend a night.

From the Past to the Future

Death and insanity also await those playing Trail Of Cthulhu, another RPG that is set during the historical 1930s against the background of the Cthulhu Mythos. There is a mystery to be

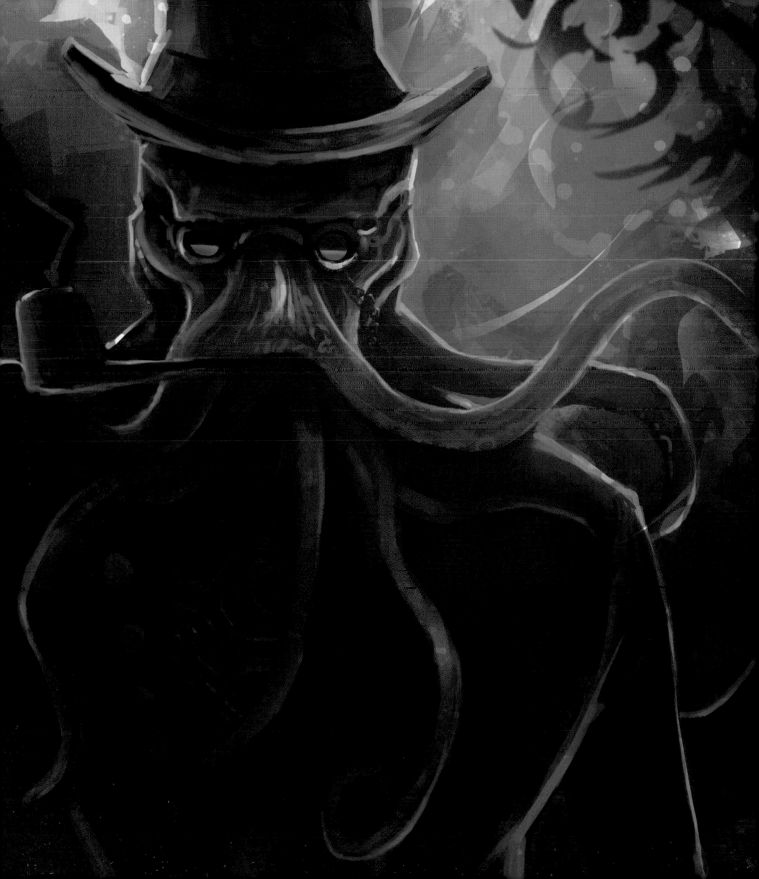

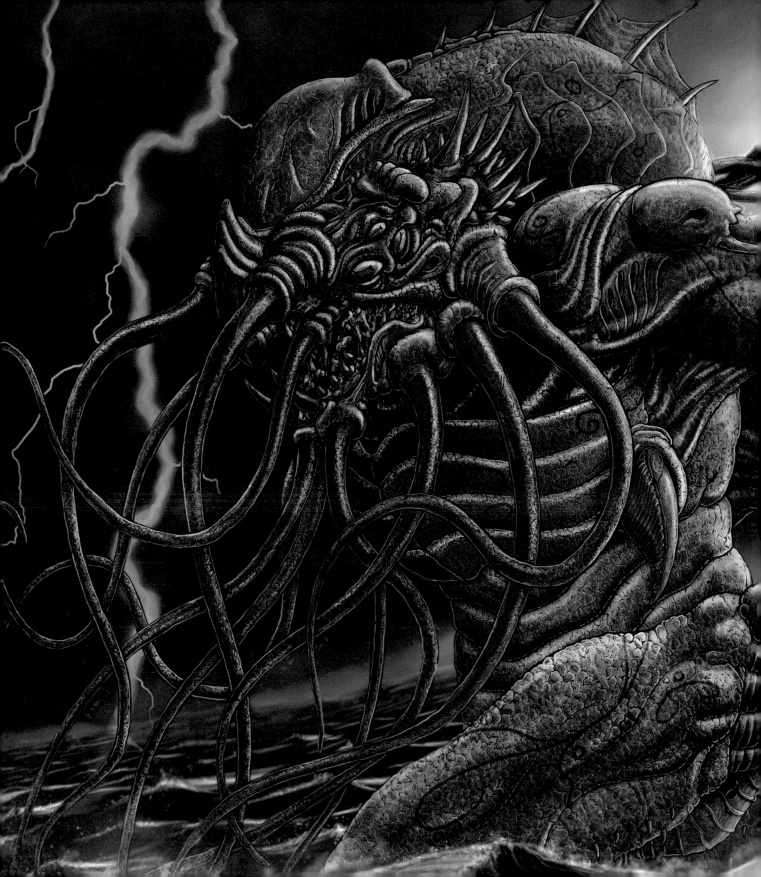

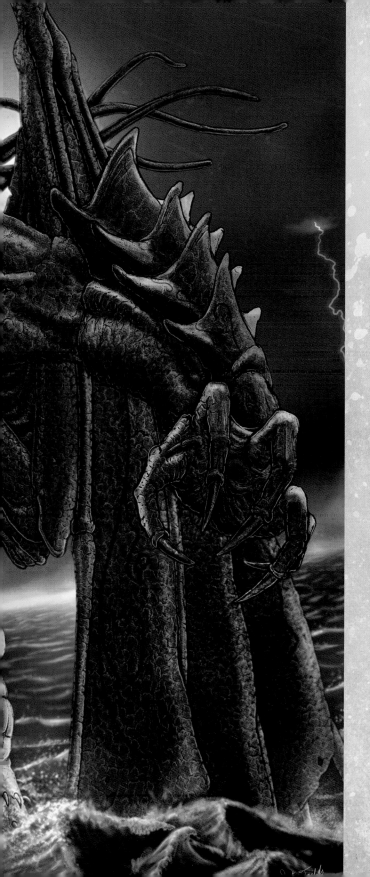

solved, but there is also the small matter of dreadful monsters and fanatical Cthulhu cults to be dealt with along the way.

The CthulhuTech RPG is a hybrid science fiction and horror RPG that mixes anime-style mecha (a genre featuring robots or machines controlled by people from inside), horror, magic and futuristic action. It is 2085 and the Aeon War is raging (referenced from the **Necronomicon** which says: 'And with strange aeons even death may die'). The alien race the Nazzadi, abetted by the Mi-Go, have invaded Earth to enslave humanity; ancient cults are running amok and, as if that was not bad enough, the Great Old Ones pick this moment to wake up and try to reclaim the Earth.

Deal the Cards

There are several card games based on the Cthulhu Mythos. CoC creators Chaosium were responsible for Mythos, a collectible card game, published in 1996 that immediately picked up the award for Best Card Game of that year. It is now produced by Fantasy Flight Games and called Call of Cthulhu: The Card Game, and features the customary arcane tomes, paranormal investigations, Elder Gods and dangers from beyond the stars.

If you're a fan of the card game Gloom, there is a spin-off version called Cthulhu Gloom, featuring Lovecraftian characters and settings. Similarly to the original game, the aim is to kill off the characters on your own cards in horrifying ways. Morbidly fun!

You Definitely Won't Get Board

If old-fashioned board games are your thing, then Cthulhu can also be found in that format. You can even cross him with motor racing as in Cthulhu 500, based on the famous Indianapolis motor race. Put your pedal to the metal in your Satanic Pushcart, powered by an Engine of the Damned and driven on Radials from Beyond Space and Time. The finances, by the way, come from your Sponsor That Must Not Be Named. If you win, you are, of course, allowed to eat your unsuccessful opponents.

Meanwhile, Arkham Horror is a more traditional approach to the Mythos, an adventure board game in which players take on the role of investigators working in the Lovecraftian town of Arkham in 1926. Gates to other dimensions open and when too many have opened, an alien being appears. The goal is to defeat the aliens and close the gates. The tabletop strategy game Mansions of Madness has developed out of Arkham Horror.

Just Point and Click

Almost since the dawn of the home computer, people have been devising computer games based on the Mythos. One of the first was Dark Seed, a psychological point-and-click adventure game published in 1992 and featuring artwork by renowned Swiss surrealist painter, H.R. Giger. A sequel followed in 1995.

'The most merciful thing in the world… is the inability of the human mind to correlate all its contents.'

H.P. Lovecraft,
'The Call of Cthulhu'

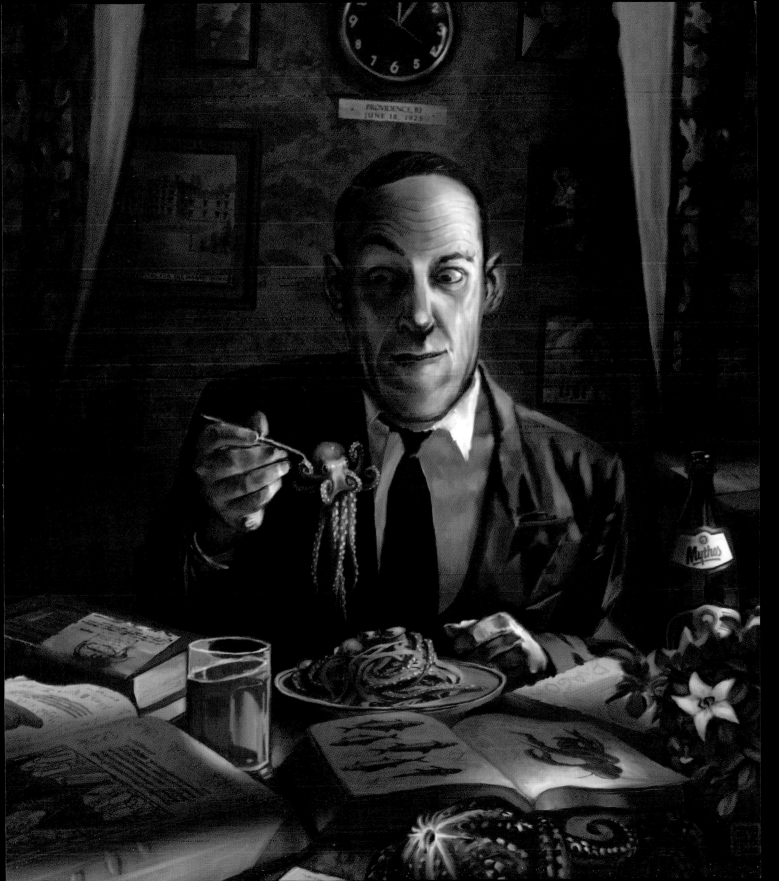

'We live on a placid island of ignorance in the midst of black seas of infinity, and it was not meant that we should voyage far.'

H.P. Lovecraft,
'The Call of Cthulhu'

1992 also saw the release of the critically acclaimed Alone in the Dark, developed for the PC. The first 3D game in the genre of survival horror, Alone in the Dark was hugely influential. Players trapped inside the haunted mansion of Derceto must find their way from the attic out of the building while avoiding all sorts of unnatural beings.

Halley's Comet and Antarctica

The 1993 adventure video game, Call of Cthulhu: Shadow of the Comet, used elements of 'The Dunwich Horror' and 'Shadow Over Innsmouth' and there are cameo appearances from the **Necronomicon**, Lovecraft and actors Jack Nicholson and Vincent Price. The game is set in 1910 when a young British photographer, John Parker, is visiting Illsmouth (an amended Innsmouth) to photograph the passage of Halley's Comet. Naturally, chaos ensues. The producers of Shadow of the Comet are also responsible for the 1995 game Call of Cthulhu: Prisoner of Ice, produced for both Windows and Apple. Set prior to World War Two, it features a young American submarine officer who rescues a Norwegian from a German base in the Antarctic that happens to be built on the Ancient Ruins of **At the Mountains of Madness**. Needless to say, this unleashes a host of problems (and monsters) for all concerned.

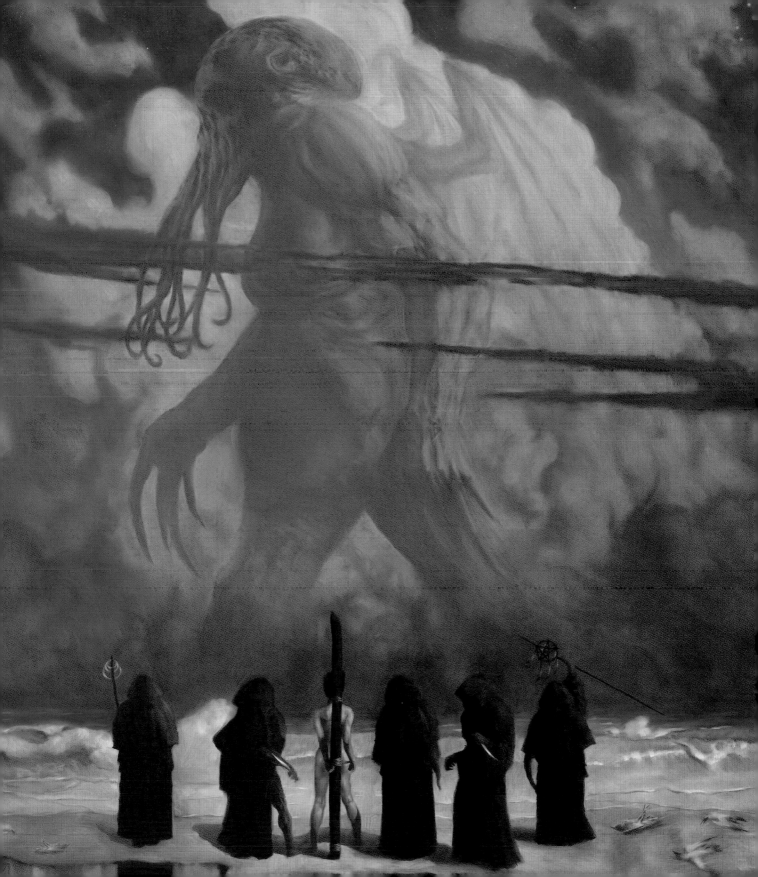

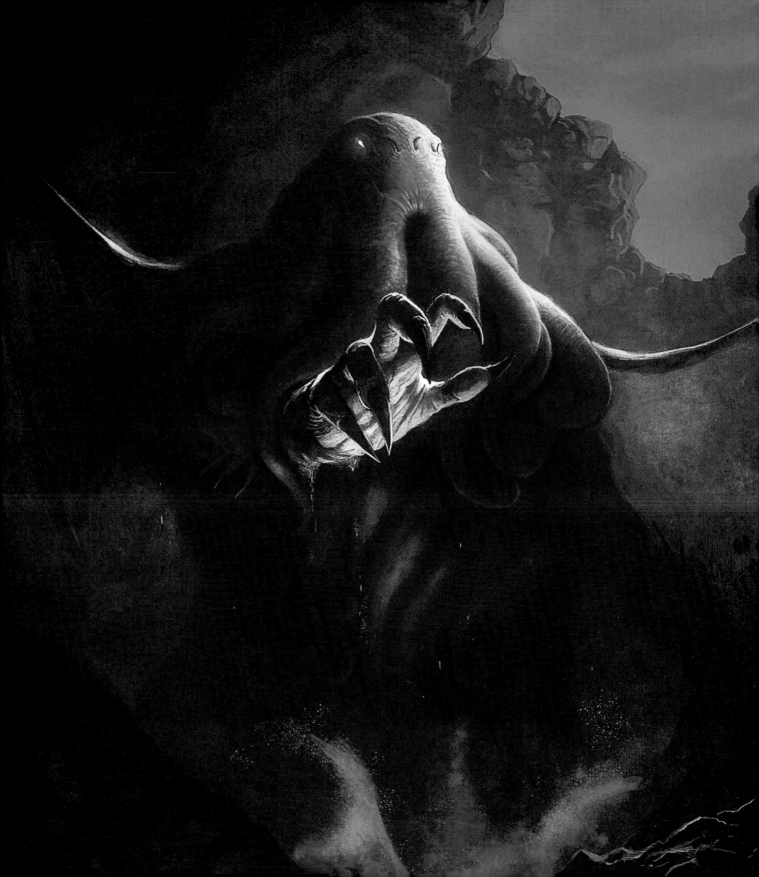

Survival of the Sanest

Call of Cthulhu: Dark Corners of the Earth, developed in 2005 for the Xbox and released a year later for PC, is a survival horror game. 'The Shadow Over Innsmouth' forms the basis for the game as a mentally unstable private detective named Jack Walters undertakes a missing person case in Innsmouth against the backdrop of the Cthulhu Mythos and all that implies.

Elementary, My Dear Cthulhu

Sherlock Homes: The Awakened, published in 2006 for Microsoft Windows, is one of the most successful Cthulhu Mythos video games. It follows the famous fictional detective and his amiable sidekick Dr Watson as they investigate a series of disappearances related to the Cthulhu Mythos.

As you can see, there's a multitude of different types of games available that have their origins in the Cthulhu Mythos. However, just be careful when you roll that dice or push that key to open a door. You never know what you might find and, after all, the Cthulhu Mythos is no game...

'The most interesting characters in Lovecraft's stories are invisible and smell bad.'

Roy G. Krenkle, fantasy artist

'I have seen beyond the bounds of infinity and drawn down daemons from the stars…I have harnessed the shadows that stride from world to world to sow death and madness…'

H.P. Lovecraft, From Beyond

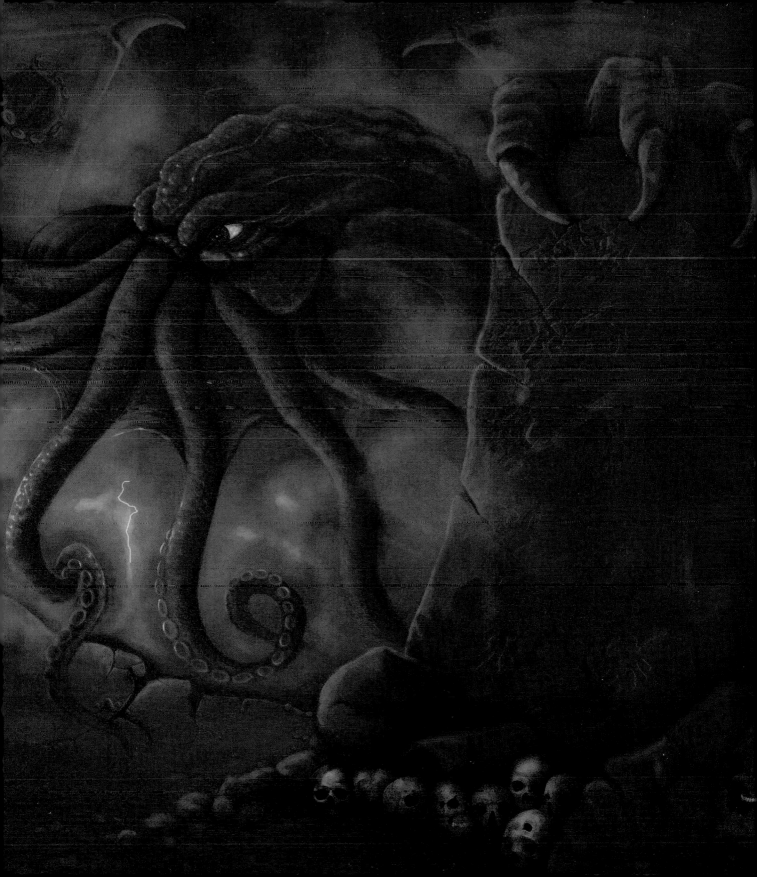

R'lyeh Good Art

How can you paint the unknowable? Well, many artists have tried and seem to have retained their sanity even after their minds have been haunted by the dark and macabre imagery of the Cthulhu Mythos. They appear to really enjoy exploring the surreal creatures and places that inhabit Lovecraft's universe.

A Thousand Words Paint a Picture

It is something of a challenge, translating the writer's words into a visual image. Of course, sometimes Lovecraft goes to town on describing a being, presenting further difficulties for anyone trying to depict the featured creature. On other occasions, he gives away little. As influential fantasy artist Roy G. Krenkle said, 'the most interesting characters in Lovecraft's stories are invisible and smell bad'. Now, that is a challenge. However, that challenge could, of course, also be viewed by an artist as an opportunity to explore the darker recesses of his or her imagination, to dispense with everyday reality and let the imagery run wild. Many have done just that.

Batrachian Loathsomeness

On the fascinating website www.tor.com, five-time British Fantasy Award Winner Dave Carson, a

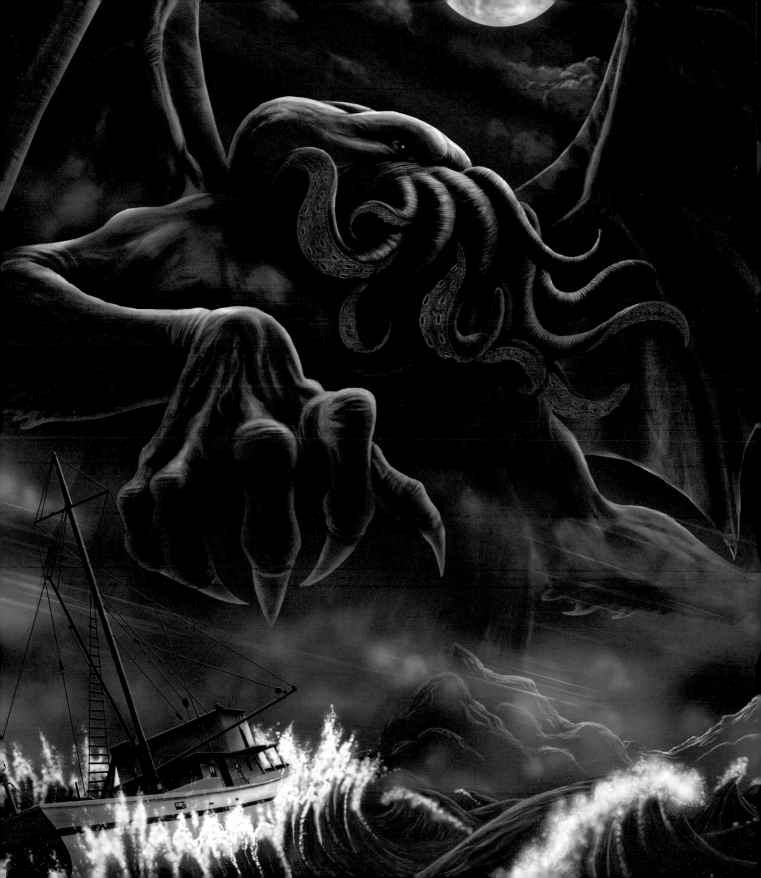

'I have harnessed the shadows that stride from world to world to sow death and madness.'

H.P. Lovecraft, From Beyond

Lovecraftian and horror illustrator, colourfully explains what is so good about working on Cthulhu Mythos imagery: 'There's batrachian loathsomeness, squamous blasphemy, leprous hideousness, fungoid unholiness, and eldritch horror. There's Cyclopean cities, decaying seaports and yawning mold-caked tombs. And then there are the wings, and worse than wings....'

The art comes in all forms and media, from pencil drawings to iPad paintings, to full colour executions where you can almost see the slime run down the canvas. There is even sculpture. American artist Bryan Moore, who worked on the movies **Nightmare on Elm Street, Jumanji** and others, has fashioned not only a terrific bust of Lovecraft but also one of Cthulhu himself.

Doomed Voyage

The artists whose work is represented in this book are amongst the best interpreters of the Cthulhu Mythos universe. Rafal Badal, for instance, captures the full horror of an awakened Cthulhu, his image of the immense monster amid broiling, red clouds dwarfing an ocean liner on what is undoubtedly its last doomed voyage (**see** pages 24–25). This image was very effectively used on the cover of the Ross E. Lockhart-edited **The Book Of Cthulhu.** Cyril Van der Haegen has the advantage of actually living in Providence, Lovecraft's birthplace and is not entirely joking when he says, ' It certainly is true that the Old Ones have descendants in the area'. He had some fun with imagining how Lovecraft came up with

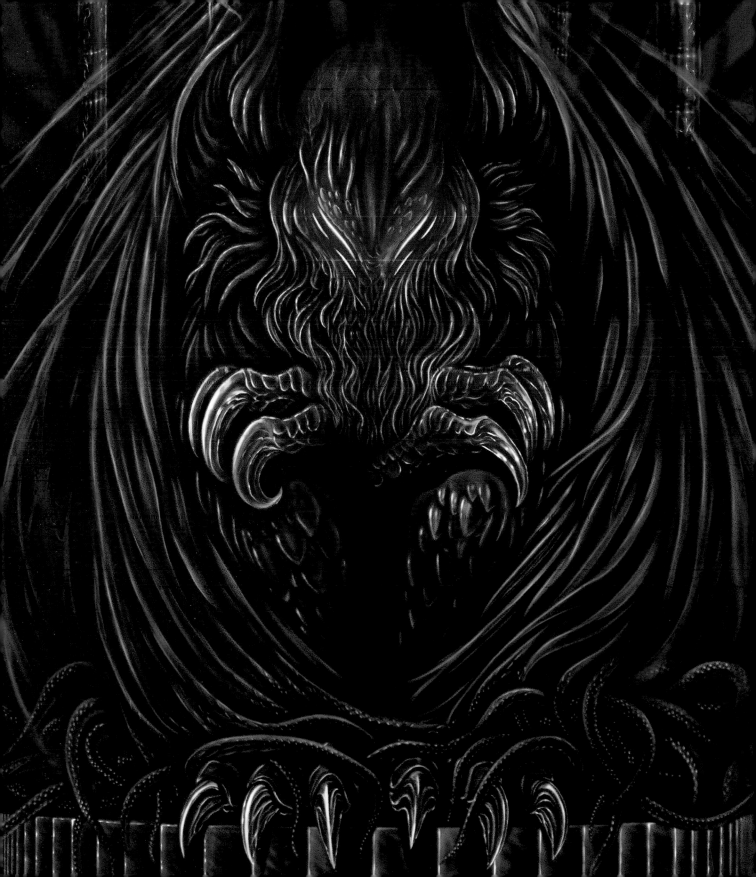

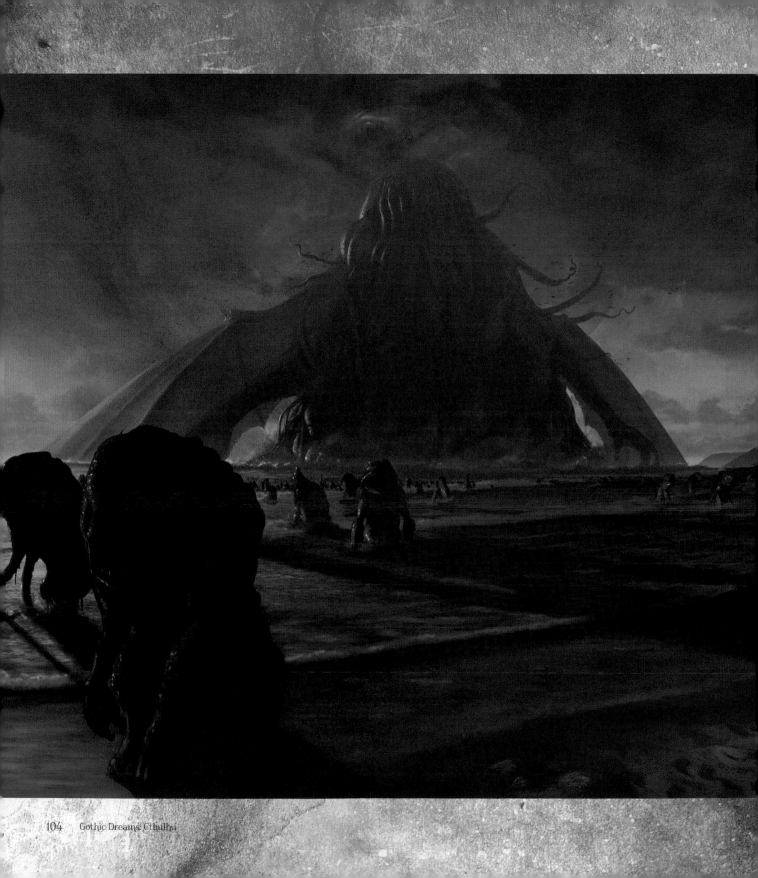

Cthulhu in his artwork ***The Birth of Cthulhu*** (***see*** page 93), and was inspired to meld N.C. Wyeth's artwork ***The Giant*** and Lovecraft's words to create an excellent Cthulhu mythos picture (***see*** page 95).

Size is Everything

The sheer size of the Great Cthulhu is displayed brilliantly in Cloud Quinot's image of a statue of Cthulhu (***see*** page 32). A tiny figure of a man stands in dumbstruck awe in front of it, emphasizing the Lovecraftian notion of humankind's sheer irrelevance in the face of such immensity. Douglas Sirois, who has illustrated the book ***Apollo***, which mixes both Greek mythology and the Cthulhu Mythos (surely Lovecraft would have been pleased), similarly shows the monstrous size of Cthulhu as he emerges from the ocean (for example ***see*** pages 18 or 36–37). The artist Gwabryel, and admirer of artists such as Frank Frazetta, also depicts the size of Cthulhu's awesome power as he sits on his throne (***see*** page 49).

Brilliantly Loathsome

Cthulhu Rising by Alex Ruiz (***see*** page 57) shows a Cthulhu with a devil's head with eyes everywhere and a body that seems to be made of tentacles – a brilliantly loathsome execution created entirely in Photoshop. If you want to know how he did it visit his Concept Monster Workshop website (www.conceptmonster.net) where there is a video of the creation. A more traditional version of the monster can be found on page 65, created by Manthos Lappas and for the

'Who knows the end? What has risen may sink, and what has sunk may rise. Loathsomeness waits and dreams in the deep, and decay spreads over the tottering cities of men.'

H.P. Lovecraft, 'The Call of Cthulhu'

really squeamish, there's the slimy Cthulhu (**see** page 107) of Kari Christensen's imagination, mostly painted on an iPad and then further developed in Photoshop.

Awesome Cosmic Deity

Part of what makes the Cthulhu games so amazing is the atmospheric artworks that go into creating their look. Rick Sardinha's sketch (**see** page 64), already mean and moody, shows the early workings of an image which would later be used by the company Wizards of the Coast. Homegrown Games utilized Peter Siedl's considerable talent in populating their Lovecraft-inspired world. Siedl's artworks include an interpretation of a Dark Young set in a misty forest (**see** page 43) and an Aztec-style Cthulhu calendar (**see** page 4).

Drawing on Fear

In complete contrast is a wonderfully executed, fun drawing by Abigail Larson (**see** page 13) of Lovecraft seated in an armchair with tentacles emerging from behind it, rats coming out of a hole in the skirting board and ghoulish eyes everywhere. Finally, Lovecraft appears again in David Hartman's cartoonesque **Lovecraft** (**see** page 28) in which the writer is dwarfed by his red-eyed creation while holding a book that one imagines is probably the **Necronomicon**.

What Ho, Cthulhu?

The Cthulhu Mythos is tailor-made for comics – mixing fantastic stories with vibrant sf art. There are not only

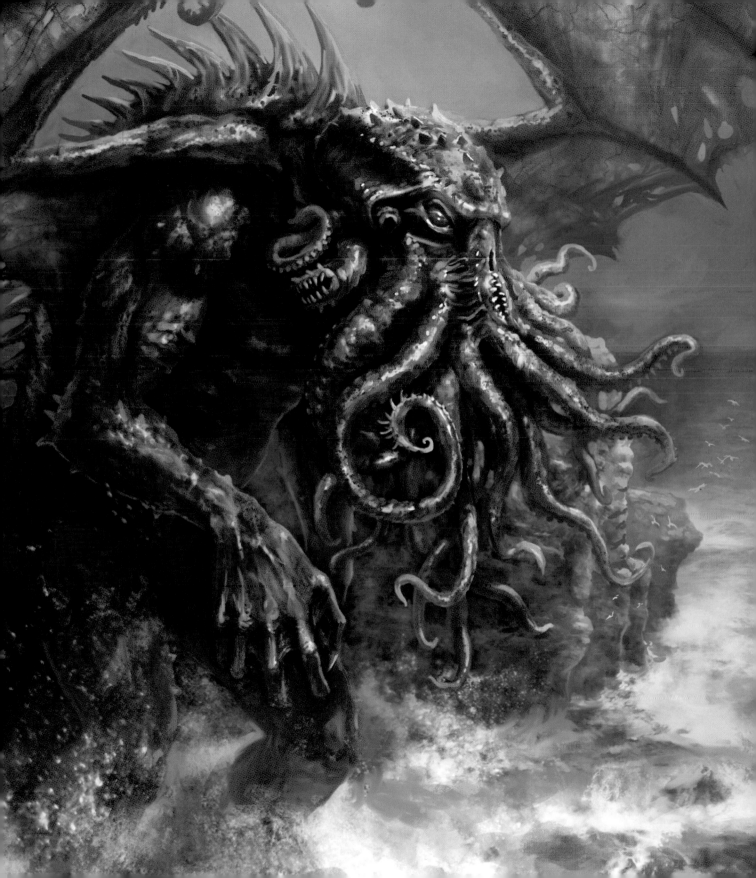

adaptations of Lovecraft stories such as the three-part **Cthulhu: The Whisperer in the Darkness**, but also new stories dealing with the Cthulhu Mythos.

The great English comic-book writer, Alan Moore, used Lovecraftian elements in **The Courtyard** and **Yuggoth Cultures and Other Growths**, as well as in **Black Dossier**, a graphic novel in the **League of Extraordinary Gentlemen** series. The story 'What Ho, Gods of the Abyss?' somewhat incongruously brings together the Cthulhu Mythos and P.G. Wodehouse's Bertie Wooster.

Hellboy and Batman

The stories featuring the character **Hellboy**, show a great deal of Lovecraftian influence, as their creator Mike Mignola readily admits. In another work by Mignola, **The Doom That Came to Gotham**, Batman finds himself faced with Lovecraftian monsters.

The British sci-fi weekly, **2000 AD**, has seen numerous instances of Cthulhu Mythos inhabitants appearing on its pages. Writer Gordon Rennie introduced the Tcho-Tcho in **Necronauts** and Lovecraft himself appears. Prior to that Grant Morrison's **Zenith** featured a struggle with the Lloigor, or Many-Angled Ones, other-dimensional beings with links to the Cthulhu Mythos.

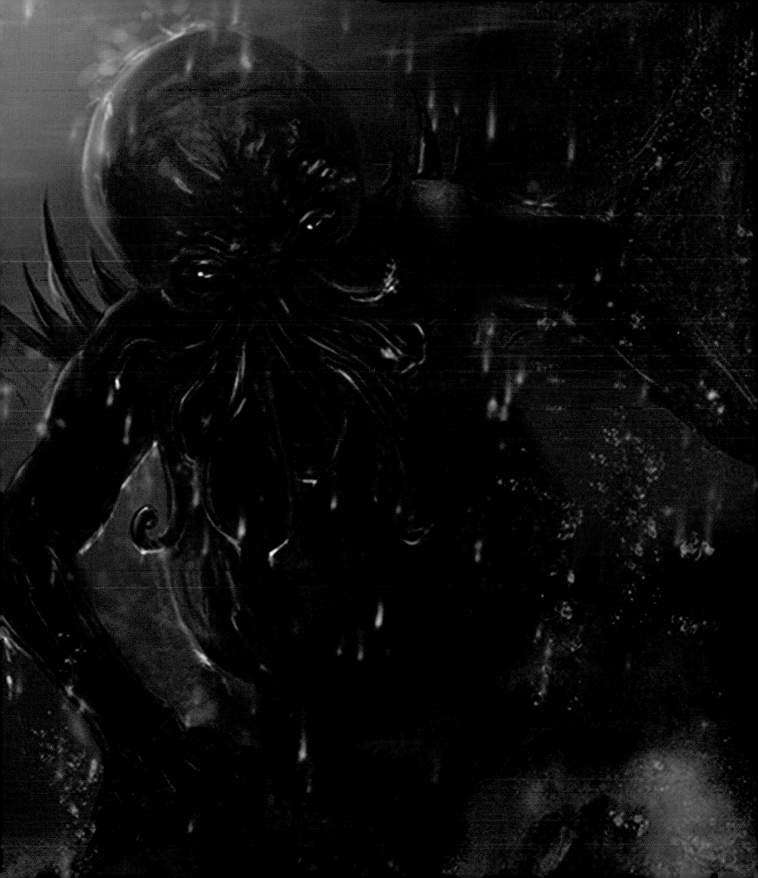

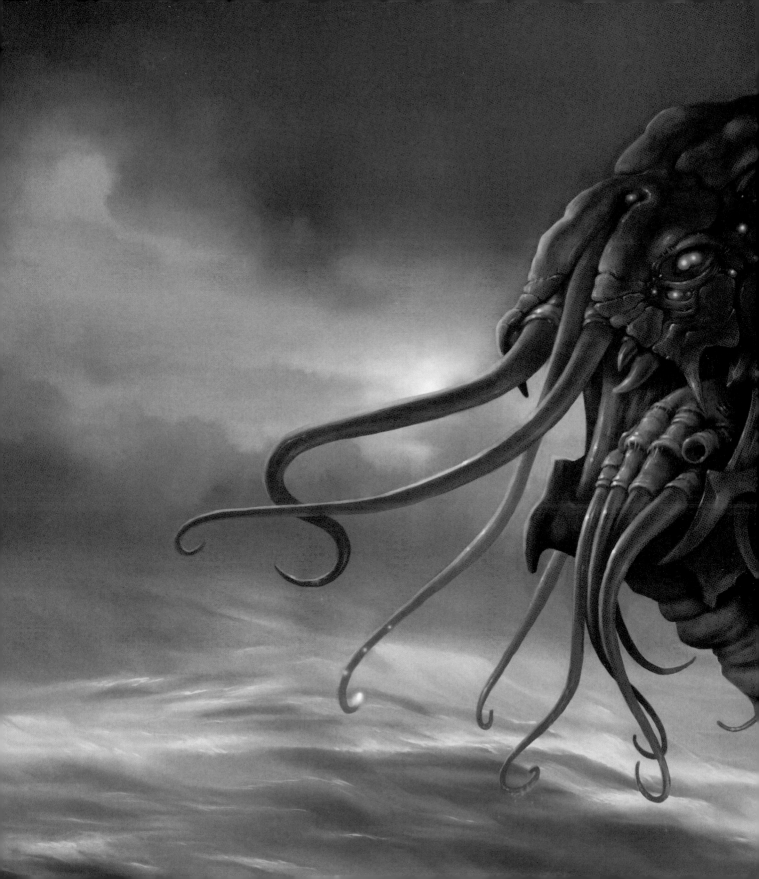

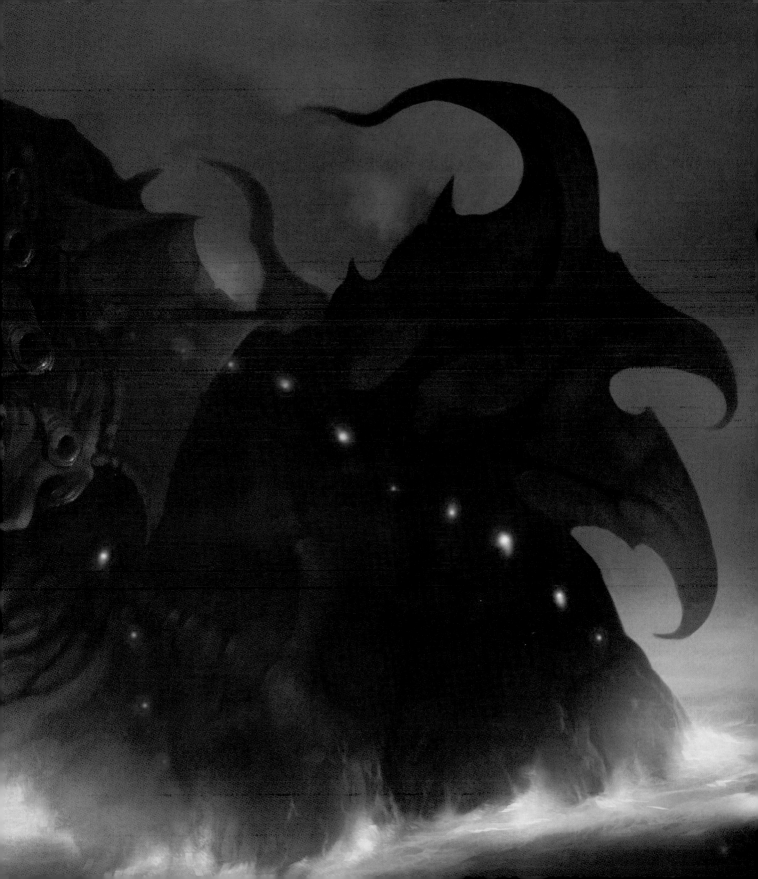

A Monster Universe

Okay you've read the books, watched the movies and played the games, but what about the music? Yes there is, indeed, a considerable amount of music that references the Cthulhu Mythos, whether in titles or lyrical content. And who knew that Cthuhlu – so terrifying in his appearance – could become a fashion icon? There's a whole universe of fun to be had.

Metal

Metal of all sorts is the natural home for such references, none more so than that of American death metal band Nile, whose 1998 album ***Amongst the Catacombs of Nephren-Ka*** refers directly to the Lovecraft story, 'The Outsider'. In the Mythos, Nephren-Ka was an Egyptian Pharaoh whose cult was so unspeakable it has been expunged from history.

Even just adding a little Cthulhu reference to the title of a song, as Metallica did for the instrumental ***The Call of Ktulu*** on their 1984 album, ***Ride the Lightning***, lends an atmosphere to the work. Metallica again referenced the stories of the Mythos in their next album, ***Master of Puppets***, which contained a song, 'The Thing That Should Not Be', based on 'The Shadow Over Innsmouth'.

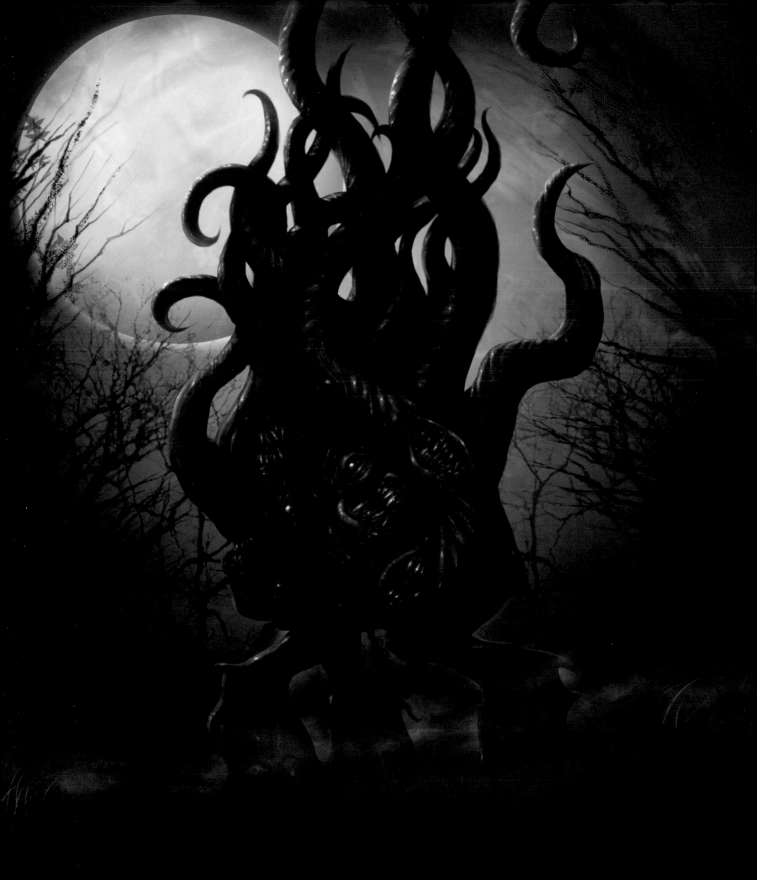

> '*The end is near. I hear a noise at the door, as of some immense slippery body lumbering against it. It shall not find me. God, that hand! The window! The window!*'
>
> H.P. Lovecraft, 'Dagon'

Ominous Chanting

In 2004, American Neoclassical darkwave/dark ambient duo Nox Arcana released an entire album based on Lovecraft's stories, as a tribute to the Cthulhu Mythos. Ominous chanting is supported by strings, pipes, drums, guitars and choirs and there are brief narratives telling the tale of an alchemist who is raising an ancient race of otherworldly beings. The unpronounceable language of the Old Ones even makes an appearance, although whether it is correctly pronounced, we will never know. Song titles include **The Nameless City**, **Cthulhu Rising** and **Yog-sothoth**. Nox Arcana pay further tribute to the Cthulhu Mythos on their 2009 album, **Blackthorn Asylum**.

More Mythos Metal

Many other bands are fond of the Mythos. Californian stoner metal band High on Fire based a couple of tracks on their 2005 release Blessed Black Wings on Lovecraft's **At the Mountains of Madness** and 'The Hound'. Mythos influence can be found on **The Chthonic Chronicles**, by English metal band Bal-Sagoth, while the music of Canadian rock band, The Darkest of Hillside Thickets, consists mainly – and somewhat bizarrely – of what are often tongue-in-cheek homages to Lovecraft and the Mythos. Meanwhile, Finnish doom metal band Thergothon featured four songs based on Lovecraft and the Mythos on their 1992 album **Stream From the Heavens**. Their demo the year before bore the title **Fhtagn-nagh Yog-Sothoth**.

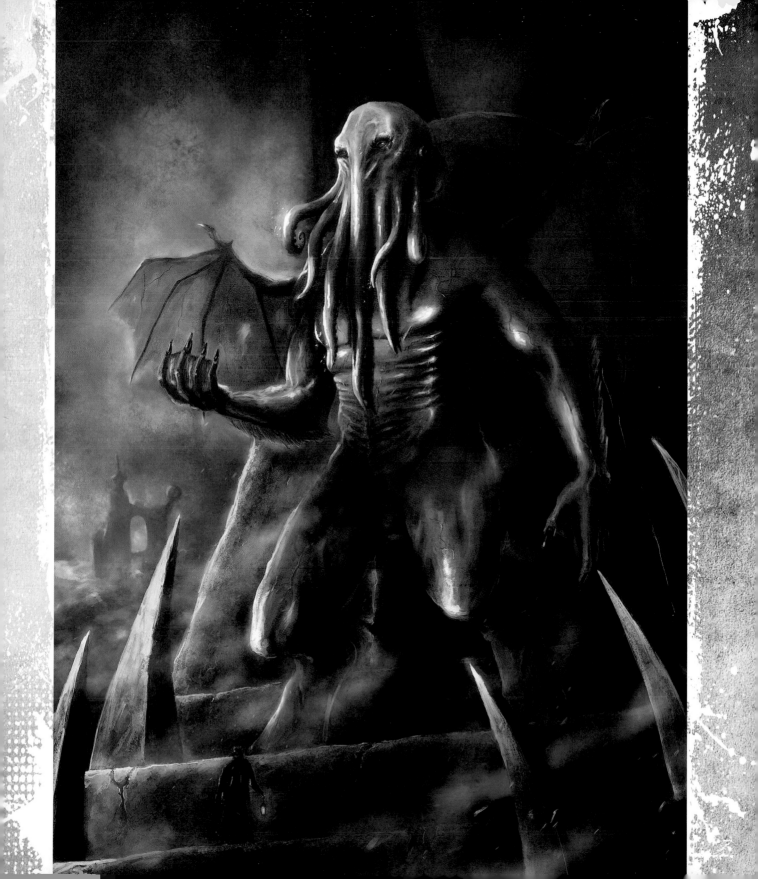

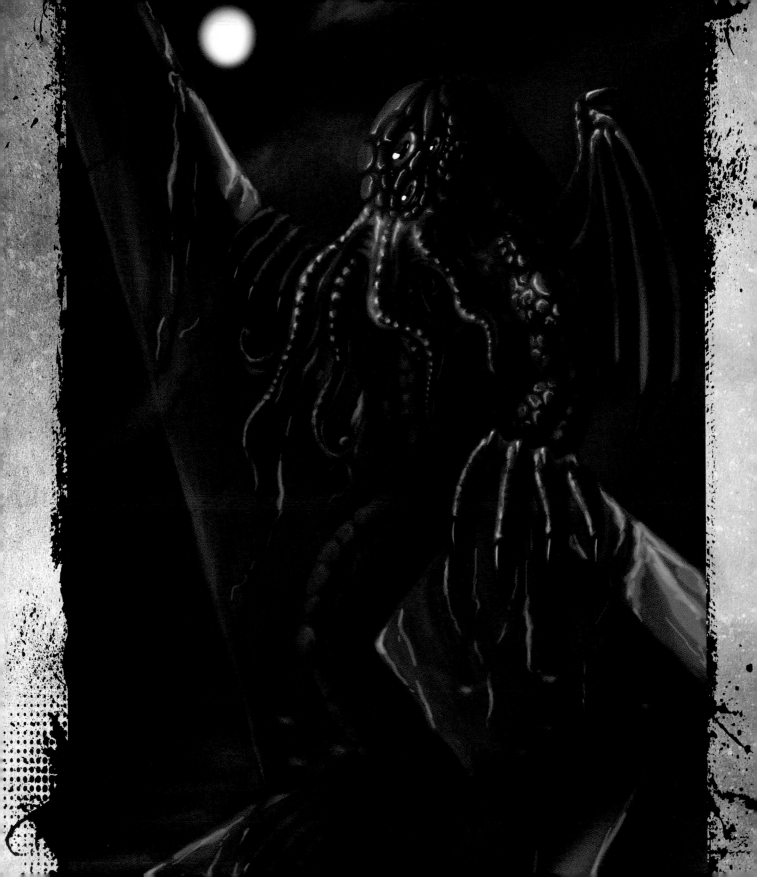

The Mad Arab

'Kutulu (The Mad Arab, Part 2)' can be heard on Mercyful Fate's 1996 album **Into the Unknown**, 'The Mad Arab' part one having appeared on **Time** the previous year and extreme metal band Cradle of Filth sing 'Cthulhu Dawn' on their 2000 album, **Midian**. Meanwhile, Nephren-Ka rears his ugly head again on the 2007 album, **The Wolves Go Hunt Their Prey**, by German Gothic metal band The Vision Bleak.

Mythos Musical Fun

If you want some fun at the expense of Cthulhu – never advisable – look out for the parody album **A Very Scary Solstice**, performed by members of the H.P. Lovecraft Historical Society. Titles include 'The Great Old Ones Are Coming to Town' and I Saw Mummy Kissing Yog-Sothoth'. It is doubtful if Cthulhu would be amused.

Finally, of course, there is a musical…no really! **A Shoggoth on the Roof**, is based on **Fiddler on the Roof** and written by a member of the H.P. Lovecraft Historical Society referred to only as 'He Who (for legal reasons) Cannot Be Named'.

Fashion Icon

There are plenty of T-shirts that boast designs such as 'Miskatonic University' as well as depictions of old

'You know what killed
off the dinosaurs, Whateley?
We did. In one barbecue.'

Neil Gaiman, 'I Cthulhu'

tentacle-face. One online T-shirt says 'Cthulhu for President' – be careful what you wish for! The main use of Cthulhu in fashion, however, is in jewelry. There are some extraordinarily beautiful items to be found – **Necronomicon** necklaces, Cthulhu amulets, medallions and rings. Just right for impressing your fellow dancers at the Steampunk Ball.

Make It An Event

Sadly it seems as though there is more call for Cthulhu and Lovecraft conventions and get-togethers than actual events. However there are a couple of conventions which are worth checking out. The NecronomiCon is a convention that takes place on odd numbered years on a date close to Lovecraft's birthday, August 20. A whole weekend of scheduled events, film screenings, book readings and all sorts of fascinating discussions on Lovecraft's work, the mythos in general and its adaptations into various media lie in store for the enthusiastic attendees.

Another event which is still going strong is the Lovecraft Film Festival and CthulhuCon held annually in America. It's a fantastic way to bring fans together through celebrating the screen adaptations of Lovecraft's work and the Great Old Ones themselves.

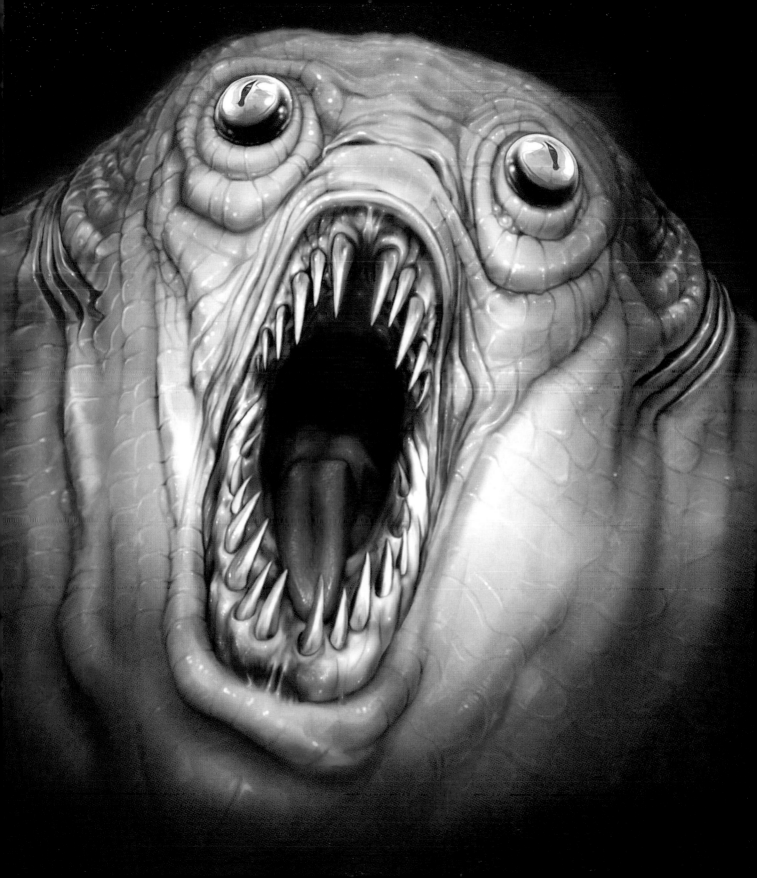

Delve Deeper... If You Dare

Now that you are spellbound by Cthulhu's call, here are some resources to help you delve deeper into the mysterious city of R'lyeh and Lovecraft's spine-tingling, nightmare-inducing world. This is just a small selection of books and websites you should check out to further your arcane knowledge of Cthulhu.

Books

There are almost as many books telling stories about or just explaining the Cthulhu Mythos as there are stone tablets in the Great Library of Celaeno, which as everyone knows is located on one of the seven stars of the Pleiades. Here are just a few to get you started, and of course we've mentioned even more in the main text of this book:

Fiction

At the Mountains of Madness: Lovecraft's novella featuring an array of Elder Beings, which provides a back story to some elements of 'The Call of Cthulhu'.

Cthulhu 2000: Jim Turner is the editor of this collection of spine-tinglingly macabre stories written by authors inspired by Lovecraft.

In Lovecraft's Shadow: The Cthulhu Mythos: featuring all the Cthulhu-Mythos fiction written by August Derleth.

Necronomicon: The Best Weird Fiction of H.P. Lovecraft: a beautifully presented volume of Lovecraft's work.

New Cthulhu: The Recent Weird: bringing together more modern fiction, edited by Sarah Monette .

New Tales of the Cthulhu Mythos: another anthology worth checking out, edited by Ramsey Campbell.

Tales of the Cthulhu Mythos: a pantheon of horror by a multitude of authors.

The Call of Cthulhu and Other Weird Stories: read the original tale by Lovecraft.

The Cthulhu Mythos Megapack; 40 Modern and Classic Lovecraftian Tales: Lin Carter brings together both Lovecraft's original tales with newer stories following in the Mythos.

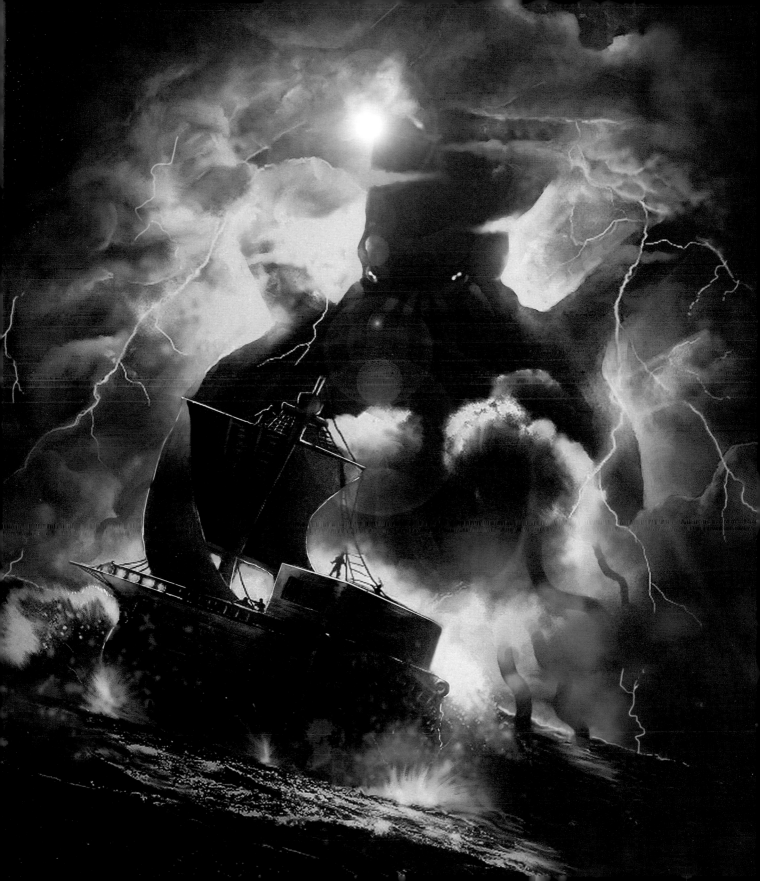

Non-Fiction

A Cthulhu Mythos Bibliography and Concordance: Chris Jarocha-Ernst records an astonishing amount of information, helping readers find Cthulhu-Mythos stories.

I Am Providence: The Life and Times of H.P. Lovecraft: pretty much viewed as *the* biography on Lovecraft, written in astounding detail by S.T. Joshi.

Lovecraft: A Look Behind the Cthulhu Mythos: Lin Carter examines which stories can be counted as part of the Mythos.

H. P. Lovecraft: Against the World, Against Life: Michel Houellebecq delves into the life of H.P. Lovecraft.

The Cthulhu Mythos Encyclopedia: A Guide to H.P. Lovecraft's Universe: Daniel Harms has created an extensive encyclopedia on the Cthulhu Mythos and how its influence on popular culture.

Websites

Before visiting forums, or if you have any problems on fan sites, visit **www.thinkuknow.co.uk** for some online safety advice. It's also worth noting that all these websites were accessible at the time of going to press, but could be subject to change/removal/being sucked into the depths of the ocean.

www.cthulhu.com: all things Cthulhu.

www.cthulhufiles.com: an index to gods, books, people, and places in the Cthulhu Mythos.

www.cthulhulives.org/toc.html: the website of the H.P. Lovecraft Historical Society.

www.hplfilmfestival.com: official website of the H.P. Lovecraft Film Festival and CthulhuCon, which has been going since 1995.

www.hplovecraft.com: the Lovecraft archive; full of fascinating links and information.

www.nethereal.de: a great website which also includes the Cthulhu Lexicon (a guide to people and creatures), Codices of the Mythos (a list of books and their contents) and When the Stars are Right (a Cthulhu Mythos chronology of events).

www.siamorama.com/lovecraft/index.htm: the Virtual World of H.P. Lovecraft.

It is also worth checking out the individual websites of Cthulhu Mythos writers. They often provide stories free of charge.

Acknowledgements

Biographies

Gordon Kerr (Author)

Gordon first met the tentacle-faced one back in the late sixties when R'lyeh erupted through the floorboards of his bedroom in Scotland during one of its brief moments in the sun. Or rather, he thought it did, but it was just a nightmare after reading a book of H.P. Lovecraft stories. He's been having nightmares again writing this book and re-visiting some scary moments from his teenage years. When he's not writing about extra-dimensional beings and hiding beneath the blankets, he scribbles books on a variety of subjects, from art to travel and history to humour. He lives in Dorset and southwest France, but knows it's only a matter of time until that knock on the door. He just knows too much…

John Harlacher (Foreword)

John is the publisher and creative director of *Weird Tales* magazine, the world's oldest magazine of dark and strange fantasy. Founded in 1923, *Weird Tales* introduced the world to writers like H.P. Lovecraft (Cthulhu), and Robert E. Howard (Conan the Barbarian), and artists like Margaret Brundage (the queen of gothic fetishism). John also makes theatre and film in NYC.

Links

Find out more about the fantastic artists, authors and sources of the quotes in this book:

www.flametree451.com

Picture Credits

The Artists

Special thanks to all the artists who have contributed artwork for this book:

Dan Harding 1 & 67; Original Artwork by **Peter Siedl** © 2010 **Homegrown Games**, a label of HRMC Management 3 & 45, 43, 46; Original Artwork by **Peter Siedl** © 2008 **Homegrown Games**, a label of HRMC Management 4 & 12t & 22t & 38t & 52t & 66t & 88t & 100t & 112t; **Gwabryel** 7, 49, 53, 54; **RJ Palmer** 8; **Misael Barbosa** 10–11; **Abigail Larson** 13; **Leah Kapounek** 14; **Barret Chapman** 16 & 17 &122b & 125b; **Douglas A. Sirois** 18, 20–21, 36–37. 39; **Claire Beard** 23; **Rafał Badan** 24 & 25; **Kostja Schleger** 26; **Diego Simone** 27; **David Hartman** 28, 69; **Arco den Haan** 30 & 101; **Eddie Sharam** 31; **Cloud Quinot** 32, 34 & 59; **Dave Oliver** 40, 113, 119; **Lukasz Pakula** 50–51, 123; **Alex Ruiz** 57; **Borja Pindado** 60, 96 & 97; **Ellena Korth** 63; **Rick Sardinha**; finished version © **Wizards of the Coast** 64; **Manthos Lappas** 65; **John Dotegoweski** 74; **Daniel Kamarudin** 76; **Wes Jones** 84; **Dino Tomic** 85; **Bryan Reagan** 86; **Steve Hamilton** 89; **Justin Fairfield** 90; **Cyril van der Haegen** 93, 95; **Keith Talbot** 99; **Carrie Hanscom** 103 & 128; **Sady M. Izé** 104; **Kari Christensen** 107; **Maria Sweeney** 109; **Jason Juta** 110–11; **Álvaro Nebot** 115, 127; **Yevgeniya Yakovleva (Sareena von Shinnok)** 116; **Eric Ridgeway** 120–21; **Mitchell Nolte** 124.

Other Picture Sources

Courtesy of/© **Photoshot** (and the following): **Davis-Films** 70, **The Movie Company** 73, **Castelao Productions** 75, 79 **Industrial Light & Magic**, 81. © **Sergei Bachlakov/Warner Bros./Getty Images**: 83. Courtesy of **Wikimedia Commons** and the following: **AdamBMorgan** 19, 29, 41; **Flax5** 30.

Recurring decorations based on images courtesy of **Shutterstock.com** and © the following contributors: **deenphoto**; **Digital-Clipart**; **Fotokostic**; **LeksusTuss**.

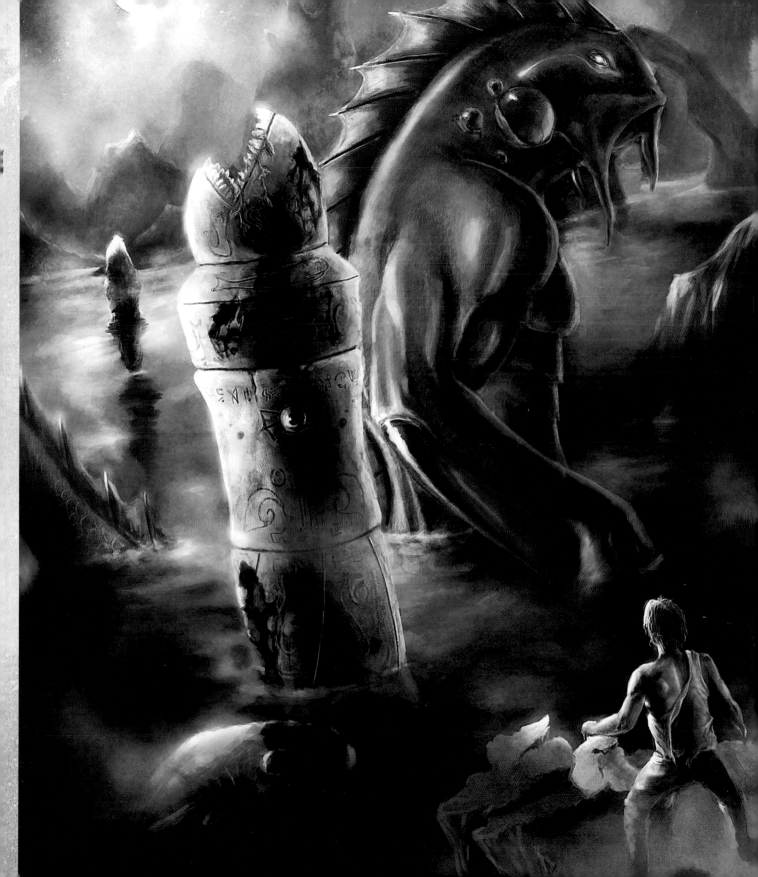